The Secrets We Keep

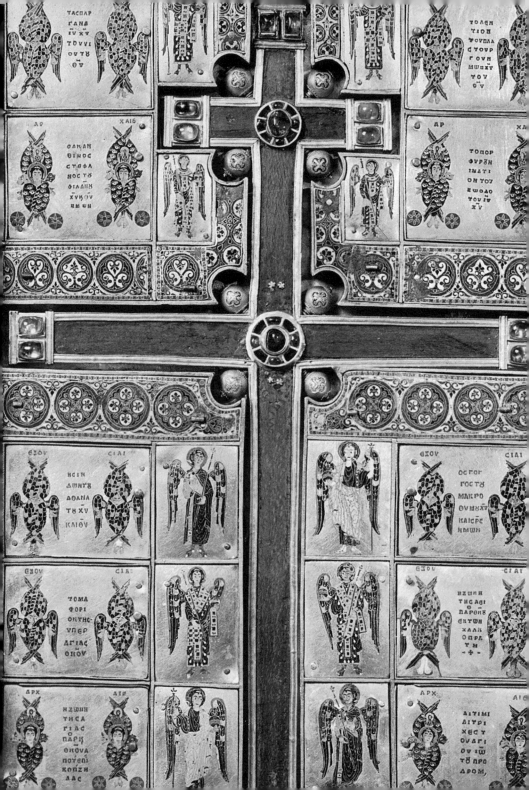

ROLAND BETANCOURT

# THE
# SECRETS
# WE
# KEEP

Hidden
Histories
of the
Byzantine
Empire

GETTY RESEARCH INSTITUTE, LOS ANGELES

*The Secrets We Keep* publishes the annual Thomas and Barbara Gaehtgens Lecture, delivered by Roland Betancourt on 4 December 2022.

This publication is supported by the Getty Research Institute Council.

**Getty Research Institute
Publications Program**
Mary E. Miller, *Director, Getty Research Institute*

**Published by the Getty Research Institute,
Los Angeles**
Getty Publications
1200 Getty Center Drive, Suite 500
Los Angeles, California 90049-1682
getty.edu/publications

Laura Santiago, *Editor*
Jon Grizzle, *Designer*
Michelle Deemer, *Production*
Karen Ehrmann, *Image and Rights Acquisition*

Distributed in the United States and Canada by the University of Chicago Press

Distributed outside the United States and Canada by Yale University Press, London

This publication was peer reviewed through a single-masked process in which the reviewers remained anonymous.

Printed in Malaysia

**Library of Congress
Cataloging-in-Publication Data**
Names: Betancourt, Roland, author. |
  Getty Research Institute, issuing body.
Title: The secrets we keep : hidden histories of
  the Byzantine Empire / Roland Betancourt.
Other titles: Hidden histories of the
  Byzantine Empire
Description: Los Angeles : Getty Research
  Institute, [2024] | Includes bibliographical
  references and index. | Summary: "With
  insights into the religious, imperial, military,
  and cultural uses of secrecy, this book
  looks at the ways secrecy manifested itself
  during the Byzantine Empire and the
  implications it has for the issues we face
  today"—Provided by publisher.
Identifiers: LCCN 2023049915 (print) |
  LCCN 2023049916 (ebook) |
  ISBN 9781606069080 (paperback) |
  ISBN 9781606069103 (pdf) |
  ISBN 9781606069097 (epub)
Subjects: LCSH: Secrecy—Byzantine Empire. |
  Reliquaries, Byzantine. | Byzantine Empire
  —History.
Classification: LCC DF552 .B48 2024 (print) |
  LCC DF552 (ebook) | DDC 949.5/02
  —dc23/eng/20231122
LC record available at https://lccn.loc.gov
  /2023049915
LC ebook record available at https://lccn.loc
  .gov/2023049916

# CONTENTS

# THE
# ALLURE
# OF
# SECRECY

In today's never-ending litany of
exposés, tell-all memoirs, and political leaks, we have come to exist in
an undeniable cult of information that delves into the arcane details of
political intrigue and deceit. Seduced by the unknowable powers of secret
things, we are continuously awaiting the next bombshell, one that will
realign our worldview, either for outrage or redemption, in an era when
many feel constantly deceived by the world. It is this thirst for occult knowl-
edge that defines the allure of secrecy, an allure that often leads to the wild
and paranoid speculations of conspiracy theories.

Conspiracy theories, while often associated with their nefarious
effects, are fundamentally a process by which people make sense of the
secret world around them. They usually deploy speculative and historically
decontextualized studies of information or datasets to produce seemingly
coherent narratives, usually of things believed to have been purposely
kept secret. Often, conspiracies appear to be so preposterous that they

are outright disregarded as satire. Yet, conspiracy theories mold the way in which subjects of a political power relate to the state and achieve a feeling of comprehension regarding all those unknowable and abstruse aspects of governance. Conspiracy theories can provide the illusion and comfort of *knowing* to a populace that feels often shielded from the truth or that has sought to resist a confrontation with the realities of a nation's history, from ingrained racism to sexual harassment. When nostalgia for a bygone era fails, conspiracy theories become the unsavory plateau for those seeking a somehow knowable, somewhat familiar sense of utopia.

However, this book is not about conspiracy theories as such. Rather, it concerns the act of secret keeping and the various historical modes of research that allow us to pierce these veils of secrecy. I am interested in the larger notion of the secrets we keep, in how secrets and secrecy operate historically in a bygone era, and in how processes of accessing secrecy often lead to imaginative, speculative narratives that break with historical propriety (that is, conspiracy theories). Yet, although conspiracy theories make up only a part of the histories of secret keeping, they nonetheless serve as an effective jumping-off point. Indeed, in order to ask meaningful questions about secrets and secrecy in the past, we must inevitably take a hard look at ourselves today and contour the very real relationships that we have fostered around narratives about secrets and secrecy. We must consider seriously the widespread popularity and impact of conspiracy theories in the modern world, not as corruptions of history but as exercises in how a populace imagines the secret things of imperial power. By understanding the history of conspiracy theories, we can then begin to interrogate the distant past to ask how and why secrecy and secret keeping have been so seductive, and what role they play in society.

Therefore, in the pages that follow, I will take a brief look at the history of modern-day conspiracies before turning to one intriguing exemplar from the Middle Ages. Through this prologue, I wish to make clear the stakes of this book in modern terms, as I seek to establish with care and nuance the allure of secrecy and the challenge of historical work and research that faces the humanities today. The main body of the book considers the various poetics of secrecy and concealment in Byzantine history, understanding how they often occur within the power dynamics of the state and how broader audiences are often placed in carefully staged mazes to try to access those secrets, either through imperial propaganda,

Betancourt

pageantry, or ritual. Finally, in the epilogue, I will return to many of the issues laid out here to reflect on the *challenge of history*—that is, on the challenge of doing historical research into secrets and secrecy when so many of our methods and strategies of recuperation have been co-opted and misused by bad-faith actors and conspiracy theorists today.

## A BRIEF HISTORY OF MODERN-DAY CONSPIRACIES

In the mid-2000s, WikiLeaks, Anonymous, Julian Assange, and Edward Snowden glamorized the information cult.[1] Whistleblowers, like former US soldier Chelsea Manning, earned much respect (or derision) as figures who sacrificed livelihoods and freedoms to reveal the truth.[2] These figures spoke truth to power. Instead of pushing against US imperialism through acts of terrorism, the whistleblowers simply made information that had been kept concealed accessible. Yet, what is perhaps most fascinating is that this was not information purposely hidden for its uniqueness; rather, it was an archival mass that reflected the ongoing, status quo workings of empire in its callous mundanity.

In recent years, brazen conspiracy theories have taken center stage in the global political sphere, emulating the figuration of the whistleblower to spread a distrust of government and institutions while parroting millennia-old stereotypes and speculations about abuses of power. These conspiracies have used a glamorized idea of revelation and disclosure of secrets not to resist imperial power but to attack and further oppress marginalized groups. QAnon, for example, the niche conspiracy theory that saw its inception sometime in autumn of 2017, has continued to receive troubling global attention.[3] While seemingly unique, QAnon hacked the figure of the whistleblower and became a cynical inversion of it. QAnon took the resistance against imperial power through tactics of revelation made by the whistleblower and turned that resistance into a rhetorical model for organizing attacks on marginalized groups, precisely by deploying society's distrust of power and a belief in unseen nefarious agents. Emerging in the extremist online imageboards of 4chan (and later 8chan/8kun), QAnon established itself in a space that was already the radicalized formulation of other online sites, like Reddit, which had allowed for powerful spaces of community and access to knowledge. On these radical boards, known for circulating violent imagery, being wholly unmoderated, and serving as cesspools of mass-shooter manifestos, QAnon arose as a perverse parody of

the liberatory actions that the revelation of secrets had held in our society. Taking the language and rhetoric of whistleblowing and leaks, QAnon and other recent conspiracy theories exist like a deranged fiction of American politics, having more in common with fan fiction than truth.

In its most sensationalist iteration, QAnon details the workings of a secret, Satan-worshipping "cabal" of influential people who run the world through the "deep state." Members traffic children to abuse them and to drink their blood as a fountain of youth (a belief derived from antisemitic blood-libel conspiracies).[4] In its less sensationalist iteration, found casually on an Instagram or Facebook feed, the deep state is a coverup for the realities of political power and thus is at times invested in protecting high-ranking pedophiles and their sex trafficking. The latter narratives have found a particularly strong hold among yoga and health influencers and have also led to lifestyle influencers spreading a conspiracy theory of humans being trafficked via cabinets on Wayfair, a popular discount retail site.[5] Despite being highly discredited, such conspiracy theories are quite adept at taking over the imagination of many and consequently come to play important social and political roles, particularly in spreading vicious forms of transphobia, homophobia, antisemitism, and misogyny.

For several decades now, our popular culture has actively helped to normalize and spread conspiracy thinking as a valid, logical, or at least plausible form of intellectual thought. Throughout the 1990s and early 2000s, books such as Milton William Cooper's *Behold a Pale Horse* (1991) and Jim Marrs's *Rule by Secrecy: The Hidden History That Connects the Trilateral Commission, the Freemasons, and the Great Pyramids* (2000) littered the tables of popular bookstores across the United States. In these books, we find the kernels of deep-state conspiracies comingled with apocalypticism and millenarianism. The books helped to mainstream paranoid views of the state, which took fragments of political critique and whistleblower rhetoric to chart out gripping narratives about the secrets of the state and elite, secret societies. During this period, ideations of the Illuminati, Freemasons, and Knights Templar also found a sleek outlet in Dan Brown's series of Robert Langdon novels, including *Angels & Demons* (2000) and *The DaVinci Code* (2003), along with their filmic adaptations.

These realms of our popular culture not only speak to a widespread interest but also help disseminate and normalize a tantalizing form of thought where narratives out of midcentury science fiction can feel like

Betancourt

reality. The History Channel's *Ancient Aliens* (2009–present), which has been on the air for well over a decade now, is perhaps the most notorious example of conspiracy theories being slyly passed off as historical fact.[6] Belittling the immense achievements of ancient civilizations, this series overlooks the massive labor forces (oftentimes via institutions of slavery) that have built the monuments of ancient Egypt or the Maya to baselessly attribute these works to quasi-divine, extraterrestrial intervention. Scholars have repeatedly called out the racism often motivating these pseudo-archaeological theses, yet such shows continue to be produced.[7] They also still garner interest, as attested by the popularity of *Ancient Apocalypse*, launched in late 2022 on Netflix. This show uses a documentary format to present another conspiracy theory, postulating that an advanced Ice Age civilization, wiped out by comets, is responsible for passing along all forms of knowledge to the world's ancient civilizations.[8]

Catering to new generations, YouTubers have also popularized newer, more palatable forms of conspiracy theories that deploy this type of thinking in everyday life. Shane Dawson (one of the first major figures on the platform), for example, has pieced together and widely disseminated a brand of conspiracy theories that are less focused on aliens and overlords and more on everyday events—ranging from the alleged reuse of pizza at Chuck E. Cheese to the deceptive falsehood that California wildfires have been the result of laser-weapon strikes.[9] While Dawson originally began his career with insensitive comedy skits and various types of vlog videos, his work came to harness long-form amateur documentaries on fellow YouTubers and a series of conspiracy videos that have become synonymous with his online persona. This conspiracy series became so central to Dawson's brand that it became the namesake of his first makeup palette, the Conspiracy palette, produced with fellow YouTuber and makeup entrepreneur Jeffree Star.

Even Netflix's wildly popular documentary *The Social Dilemma* (2020), about social media, plays with these feelings of social unease and the unveiling of cryptic controls, here personified in the algorithms of our technological addictions in order to sensationally pull back the curtain on our manipulation. Little shared in the documentary is new or groundbreaking. Yet, its cinematic style is efficacious, precisely because it often reads as a YouTube conspiracy video. Facebook, albeit in its own self-interest, even decried *The Social Dilemma* as a "conspiracy documentary."[10]

Today, the social media juggernaut TikTok has led to the widespread promotion of conspiracy theories among Gen Z. For example, seeming evidence of lizard overlords permeates the video-sharing platform, as users share doctored videos that purport to show signs of the lizards' presence among us, like a news anchor's eyes becoming reptilian in their blinks. This conspiracy thinking has seeped across various cross-sections of the United States's popular imaginary. Take the widespread theories about the Denver International Airport being either a postapocalyptic bunker or a hub for our lizard-people overlords. These conspiracies are so popular that they have even led the airport to produce a section of its website showcasing them, titled the "DEN Files."[11] The images on the "DEN Files" site also grace the halls of the terminals as banners, found over construction sites with tongue-in-cheek calls to "Learn the Truth" and asking, in one instance, "Construction? Or Cover Up?"

Repeatedly, laughable conspiracies have proven themselves to impact our world in very dangerous ways. The 2019 Facebook event–turned-internet meme, "Storm Area 51, They Can't Stop Us All," quickly went from joking sarcasm to a real threat to public well-being as desires to raid the US military base in the Nevada desert mounted in popularity.[12] And the attributions of COVID-19 to 5G network infrastructure have promulgated as quickly as the suggestion that 9/11 was an "inside job" did about twenty years ago, a case that set a dangerous precedent.[13] For instance, on Christmas Day in 2020, a suicide bomber in Nashville cited the existence of lizard people and extraterrestrial attacks before blowing out an entire street in what appears to have been an assault on internet and cell infrastructure.[14] Throughout the following years, the country has seen repeated attacks on our power infrastructure by antigovernment extremists, groomed by conspiracy theories.

Perhaps the most well-known and comical Gen-Z conspiracy theory is the eponymous "Birds Aren't Real," a satirical social movement advocating the belief that birds have been replaced with reconnaissance drones to spy on our everyday lives. This is a parody conspiracy theory, serving as a response to the widespread embrace of conspiracy theories on social-media platforms.[15] Indeed, such theories abound. Major trends on TikTok include a wide body of speculation around the so-called Simulation Theory, the idea that we are living in a simulated universe and are just background or supporting characters. Many of these videos focus on identifying glitches

Betancourt

in the matrix or lead into closely affiliated conspiracies surrounding the existence of parallel universes and our ability to jump across them. These trends dovetail into large-scale interests in astrology, astronomy, and quantum mechanics that have led to various practices like "randonauting" or "reality shifting," which can only be described as a sort of digital formulation of magical realism.[16]

### BYZANTINE CONSPIRACIES

Owing to my work as a historian of the art and culture of the Byzantine Empire, the discursive relations to political power mapped out by conspiracy theories are deeply familiar, as they point to the complex ways in which texts and visual culture formulate political identities and negotiate social tensions. By historicizing these modern-day conspiracy theories, we are better able to contextualize how they have become normalized across various sectors. This work allows us then to look upon the distant past and ask what lessons it can offer us about secret keeping and those obscure, occult, or arcane aspects of the past for which few records exist and for which the semblance of truth is not an easy matter.

Key to this discussion is a fascinating late sixth-century text, known today as the *Secret History* and said to have been written by Procopius of Caesarea.[17] Procopius was the court historian of the Byzantine Empire's best-known rulers, Emperor Justinian and Empress Theodora. In his other two books, *History of the Wars* and *On Buildings*, Procopius recounts the magnificent achievements of the imperial couple, telling us how Justinian conquered much of the Mediterranean and describing the impressive buildings that the two rulers built or restored across the empire.[18] These texts soberly narrate the history of imperial military power and cultural patronage, a tale befitting an emperor.

In the *Secret History*, however, the author presents another story of the imperial couple, telling us that while he has recounted all the deeds of the empire in his other books, he now wishes to divulge what *actually* happened.[19] Using a tone veiled in secrecy and urgency, Procopius says in his prologue that while those people were still alive it would have been unbearable for him to share this information because it would have been impossible to elude their spies and avoid a most painful death. In taking on this task, Procopius reflects that as the story becomes ancient history, he fears he "shall earn the reputation of being even a narrator of myths

and shall be ranked among the tragic poets."[20] Nevertheless, he sees it as his moral duty to recount these things in "good faith" and "in dealing with the facts."[21] From there he goes on to tell of all the corrupt things done by Justinian, Theodora, and the many figures of their court. Procopius's prologue features the same hallmarks of any modern-day conspiracy theory. First stating a first-hand knowledge of classified government activities, the author then purports to tell readers everything that their official history books deceived them into believing.

Procopius describes Justinian's rule as that of "the demon who had become incarnate in Justinian."[22] If anyone were to believe that this was meant just metaphorically, he writes later in the text that those who spent time with the emperor late into the night would see a ghost instead of his bodily form. And others would see his body rise from the throne and start pacing while his head disappeared from his body. Much like the blood-drinking, Satan-worshipping cabal of QAnon's theories, the Procopian antecedent demonstrates a political critique interwoven with the demonic and the supernatural. In fact, many historians have acknowledged how the *Secret History* presents important evidence of critique and dissent in the otherwise-rosy depiction of Justinian by Procopius and other sources.[23]

Much like what is found across extremist message boards today, the *Secret History* features a deeply misogynistic treatment of women, particularly of Empress Theodora, whom Procopius attacks extensively for her moral depravity and sexual promiscuity.[24] There, for instance, Procopius details at length the various sexual acts that Theodora engaged in, writing at one point that she lamented that the holes in her nipples were not larger so she could also have sex with them. And from there, he goes on to say that although Theodora often conceived, she deployed all known techniques to immediately induce an abortion.[25] Such passages shed a great deal of light on conceptions of gender and sexuality, and they hint at the extensive knowledge about birth control that, while evidenced in medical texts, was heavily criticized or denied by either religious or imperial authorities at the time.[26]

Furthermore, Procopius's text demonstrates a motivated attack against the imperial family, one that can be attributed to Justinian and Theodora's emergence from the lower classes of Byzantine society into the imperial rank. Thus, it speaks to a class differential where the established elite, like the wealthy Procopius himself, sought to belittle and attack Justinian

and Theodora, deeming them unworthy of such an august position. The fact that Procopius presents this information as if revealing a secret reminds us how established ranks of power will use the rhetoric of whistleblowing and secret revelation to attack those who are seen as having too much power for their social status, often placing themselves as the victims in the story and deploying a series of gendered or class-based stereotypes to contour their attack.[27]

Historians have often downplayed the political and cultural role of the *Secret History* on Byzantine society, stressing that the text received little circulation in the medieval period, and certainly little to none in the age of Justinian and that of his immediate successors.[28] Many historians believe that the text was composed for an elite audience associated with the court as humorous parody. Moreover, the *Secret History* has been understood as political satire and hyperbole rather than as having any grounding in truth. The fact that the text repeats ancient literary characteristics, cites various mythological stories, and states paranormal activities as patent truths has been used to ignore the idea that the *Secret History* held any credibility to medieval authors, and the assumption is that it was rarely read. Yet, the tenth-century lexicon, known as *The Souda* (something between a dictionary and an encyclopedia), repeatedly cites its stories and suggests a readership and interest in this odd text beyond that which historians have recounted.[29] That said, even if the text was read, what was its purpose? To put it in crudely modern terms, the lingering question has always been: Is the *Secret History* an intelligence dossier or a conspiracy theory?

In his official history of Justinian's *Wars*, Procopius even muses upon conspiracy theories when reflecting upon the period during which the plague befell Constantinople. The full passage is fascinating in its own right for its candid accounts of social distancing and quarantining during the period. Intriguingly, Procopius begins his account of the pandemic by describing first all the misinformation and superstitions that were spreading across the empire's capital during the outbreak, writing:

> During these times there was a pestilence, by which the whole human race came near to being annihilated. Now in the case of all other scourges sent from heaven some explanation of a cause might be given by daring men, such as the many theories propounded by those who are clever

in these matters; for they love to conjure up causes which are absolutely incomprehensible to man, and to fabricate outlandish theories of natural philosophy knowing well that they are saying nothing sound but considering it sufficient for them, if they completely deceive by their argument some of those whom they meet and persuade them to their view. But for this calamity it is quite impossible either to express in words or to conceive in thought any explanation, except indeed to refer it to God.[30]

These incomprehensible causes and "outlandish theories of natural philosophy" speak to the efficacy of such speculative narratives to make sense of a calamity that seems to overstep the presumed bounds of nature. What we see here is the emergence of conspiracy theories out of a confrontation with a condition of unknowing, a matter to which I shall return across this book.

As a historian looking comparatively across time at narratives about alleged secrets and theories, I am struck by the *Secret History*'s deeply familiar hatred and deceit. Thanks to the lessons of the present, I can better appreciate how Procopius's outlandish text could have had a palpable hold and convincing power over a Byzantine subject, despite its over-the-top fabrications. The *Secret History* is a cautionary tale about how certain strategies of hatred persist over time, manifesting themselves in various forms with the same tropes and characters. It reminds us of the very real efficacy that such sensational and seemingly outrageous texts can have. It is often easy to laugh off the ludicrous stories promoted by conspiracy theories. However, these patterns recur precisely because they are efficacious at seducing and enthralling masses, driven by the promise of uncovering their own secret histories.

Rhetorically, the *Secret History* reads a lot like a cross between a modern conspiracy theory and one of those popular exposés on Donald J. Trump's White House, like John Bolton's *The Room Where It Happened: A White House Memoir* (2020) or Bob Woodward's *Rage* (2020). While these modern and medieval texts each have different positions to history and definitions of truth, they share a language of revelation and positioning similar to that of an eyewitness account. In their own and specific historical contexts, they tap into wider societal desires for an inflection point or event that will change the course of history. It seems that when the feeling of political

efficacy fails and a stifling experience of learned helplessness takes over, readers take comfort in the idea of a messianic morsel of data that will change the course of history through its very revelation.

### SECRECY AND THE HISTORIAN

In the face of conspiracy theories, I have repeatedly asked myself: How can I ensure that the nuance and historical depth of what I do as a historian enter into the public sphere? The answer seems to be that approaching conspiracy theories as a corruption of reality is not very efficacious. Instead, we must see them for what they are: noxious literary texts that attempt to mediate a divide between our lived experiences and the fear of not knowing, of being deceived by secrecy.

Conspiracy theories gain their efficacy not from the stories they tell or the evidence they marshal but through the discursive, linguistic, and historical methods they use to tell those stories. Conspiracies must be assessed by their *verisimilitude*, by the appearance of being true. In other words, conspiracies gain their efficacy through aesthetic judgments upon their textual and visual presentations. As such, they belong squarely in the realm of humanistic inquiry, urging us to understand how aesthetic determinations on verisimilitude work to validate purported realities.

In a medieval work of art, which seeks to promote the might and power of an empire, the viewer is seduced by the material, compositional, iconographic, and epigraphic evidence into believing this narrative. There is hardly any room here for some lofty, objective iteration of truth; instead, all judgment is dependent on the convincing verisimilitude of the object. As historians of art, we look upon our objects to understand the narratives and ideas that they seek to promote, and we consider their efficacy in those formulations and how they were handled by their patrons and viewers alike. But we also work to reveal the secrets those objects keep, seeking to tell the stories of their material facture and the invisible labor obscured by imperial patronage; we articulate the tensions they generated between their viewers and patrons, and we use them to better comprehend whether we should trust or follow the textual sources of the periods in which they were made.

That is to say, the history of art is often contoured around the deceits of objects and the lives they have led, and we have produced complex methodological strategies for understanding these dimensions of the work of art.

As historians, we rarely echo what our sources tell us; instead, we seek to look beyond art and texts in order to articulate all that has been left unsaid. It is the role of the art historian to look at a work of art and speak for all the elements that purposely cannot be deduced from its surface.

In this book, my goal is to foreground the function of secrecy as an analytical tool for thinking through works of art so that it might lead us to a confrontation with the gripping allure of secrecy across time and the ever-complex challenges of the historian's craft. In the context of our modern world, rife as it is with conspiracy theories and deceit, it is my hope that this study on secrecy in Byzantium can better allow us to understand the role of history today and the unique possibilities offered by our work as historians of art.

**NOTES**

1. In addition to the extensive popular coverage, see Lawrence Quill, *Secrets and Democracy: From Arcana Imperii to WikiLeaks* (New York: Palgrave Macmillan, 2014); and Christian Cotton and Robert Arp, eds., *WikiLeaking: The Ethics of Secrecy and Exposure* (Chicago: Open Court, 2019).

2. Chelsea Manning, *README.txt* (New York: Farrar, Straus and Giroux, 2022).

3. The literature on QAnon is extensive and varied. For a brief introduction, see Kevin Roose, "What Is QAnon, the Viral Pro-Trump Conspiracy Theory?," *New York Times*, 3 September 2021, https://www.nytimes.com/article/what-is-qanon.html.

4. Tal Lavin, "QAnon, Blood Libel, and the Satanic Panic," *The New Republic,* 29 September 2020, https://newrepublic.com/article/159529/qanon-blood-libel-satanic-panic.

5. Ej Dickson, "Wellness Influencers Are Calling Out QAnon Conspiracy Theorists for Spreading Lies," *Rolling Stone,* 15 September 2020, https://www.rollingstone.com/culture/culture-news /qanon-wellness-influencers-seane-corn-yoga-1059856. See also Stephanie McNeal, "The Conspiracy Theory about Wayfair Is Spreading Fast among Lifestyle Influencers on Instagram," *BuzzFeedNews,* 13 July 2020, https://www.buzzfeednews.com/article/stephaniemcneal/wayfair-qanon-influencers-instagram.

6. For critiques of the show, see Riley Black, "The Idiocy, Fabrications and Lies of Ancient Aliens," *Smithsonian Magazine,* 11 May 2012, https://www.smithsonianmag.com/science-nature /the-idiocy-fabrications-and-lies-of-ancient-aliens-86294030.

7. For an excellent survey of the show's history and sources, see Sarah E. Bond, "Pseudoarchaeology and the Racism behind Ancient Aliens," *Hyperallergic,* 13 November 2018, https://hyperallergic.com/470795/pseudoarchaeology-and-the-racism-behind-ancient-aliens.

8. See Flint Dibble, "The Dangers of Ancient Apocalypse's Pseudoscience," *Sapiens,* 6 December 2022, https://www.sapiens.org/archaeology/ancient-apocalypse-pseudoscience. The popularity of the show and the harm of its narratives have even led the Society for American Archaeology (SAA) to send a letter to Netflix concerning the series and its detrimental effects on the field. For the SAA's letter, see https://documents.saa.org/container/docs/default-source/doc-governmentaffairs/saa-letter -ancient-apocalypse.pdf?sfvrsn=38d28254_3.

9. Antonia Noori Farzan, "Chuck E. Cheese's Oddly Shaped Pizza Ignites a Bizarre Conspiracy Theory Viewed by Millions on YouTube," *Washington Post,* 13 February 2019,

https://www.washingtonpost.com/nation/2019/02/13/chuck-e-cheeses-oddly-shaped-pizza-ignites -bizarre-conspiracy-theory-viewed-by-millions-youtube; and Reuters staff, "Fact Check: California Wildfires Were Not Caused by 'Powerful Lasers,'" Reuters, 31 August 2020, https://www.reuters.com /article/uk-factcheck-california-wildfires-lasers/fact-checkcalifornia-wildfires-werenotcaused-by -powerful-lasers-idUSKBN25R1VH. On Shane Dawson's series, see Kathryn Lindsay, "These Are All the Crazy Conspiracies Shane Dawson Is Investigating in His New Series," Refinery29, 31 January 2019, https://www.refinery29.com/en-us/2019/01/223207/shane-dawson-conspiracy-theories -series-explained. For the series, see Shane Dawson, "Investigating Conspiracies," YouTube video, 11 February 2019, 1:34:29, https://www.youtube.com/watch?v=sNuKpwX6Tz4.

10.   Aatif Sulleyman, "Facebook Calls The Social Dilemma a Conspiracy Documentary, Rejects Claims It Allows Hate Speech to Spread," *Newsweek*, 6 October 2020, https://www.newsweek.com /facebook-calls-social-dilemma-conspiracy-documentary-rejects-hate-speech-claims-1536643.

11.   Denver International Airport, "DEN Files," https://www.flydenver.com/great_hall /denfiles. There is also extensive media coverage on the airport's marketing campaign using its conspiracy theories.

12.   Joshua Nevett, "Storm Area 51: The Joke That Became a 'Possible Humanitarian Disaster,'" BBC News, 13 September 2019, https://www.bbc.com/news/world-us-canada-49667295.

13.   See Rebecca Heilweil, "How the 5G Coronavirus Conspiracy Theory Went from Fringe to Mainstream," Vox, 24 April 2020, https://www.vox.com/recode/2020/4/24/21231085 /coronavirus-5g-conspiracy-theory-covid-facebook-youtube. See also Chris Bell, "The People Who Think 9/11 May Have Been an 'Inside Job,'" BBC News, 1 February 2018, https:// www.bbc.com/news/blogs-trending-42195513; and Garrett M. Graff, "9/11 and the Rise of the New Conspiracy Theorists," *Wall Street Journal*, 10 September 2020, https://www.wsj.com /articles/9-11-and-the-rise-of-the-new-conspiracy-theorists-11599768458.

14.   Reuters staff, "Nashville Bombing Suspect May Have Believed in Lizard People, Aliens-Source," Reuters, 3 January 2021, https://www.reuters.com/article/us-tennessee-blast-packages /nashville-bombing-suspect-may-have-believed-in-lizard-people-aliens-source-idUSKBN2980KA.

15.   Taylor Lorenz, "Birds Aren't Real, or Are They? Inside a Gen Z Conspiracy Theory," *New York Times*, 9 December 2021, https://www.nytimes.com/2021/12/09/technology/birds-arent-real -gen-z-misinformation.html.

16.   See Lena Wilson, "What Is Randonautica Really About?," *New York Times*, 21 July 2020, https://www.nytimes.com/2020/07/31/style/randonautica-app.html. See also Jessica Estrada, "What Is TikTok's 'Reality Shifting' Trend?," *Cosmopolitan*, 19 January 2022, https://www.cosmopolitan.com /lifestyle/a38749994/what-is-reality-shifting.

17.   On Procopius of Caesarea and the *Secret History*, see Anthony Kaldellis, *Procopius of Caesarea: Tyranny, History, and Philosophy at the End of Antiquity* (Philadelphia: University of Pennsylvania Press, 2004), esp. 142–59; and Averil Cameron, *Procopius and the Sixth Century* (Berkeley: University of California Press, 1985), 49–83.

18.   Procopius, *History of the Wars*, ed. and trans. H. B. Dewing, 5 vols. (Cambridge, MA: Harvard University Press, 1914–28); and Procopius, *On Buildings*, ed. and trans. H. B. Dewing (Cambridge, MA: Harvard University Press, 1940).

19.   Procopius, *The Anecdota or Secret History*, ed. and trans. H. B. Dewing (Cambridge, MA: Harvard University Press, 1935); see also Procopius, T*he Secret History, with Related Texts*, ed. and trans. Anthony Kaldellis (Indianapolis: Hackett, 2010).

20.   Procopius, *Secret History*, 1.4–5 (ed. and trans. Dewing, 4–5).

21.   Procopius, *Secret History*, 1.4–5 (ed. and trans. Dewing, 4–5).

22.   Procopius, *Secret History*, 18.36 (ed. and trans. Dewing, 222–23).

23.　Kaldellis, *Procopius of Caesarea*, esp. 142–59; and Cameron, *Procopius*, 49–83. See also Stavroula Constantinou, "Violence in the Palace: Rituals of Imperial Punishment in Prokopios's Secret History," in *Court Ceremonies and Rituals of Power in Byzantium and the Medieval Mediterranean*, ed. Alexander Beihammer, Stavroula Constantinou, and Maria Parani (Leiden: Brill, 2013), 376–87.

24.　On the "slut shaming" of Theodora in the *Secret History*, see Roland Betancourt, *Byzantine Intersectionality: Sexuality, Gender, and Race in the Middle Ages* (Princeton, NJ: Princeton University Press, 2020), 59–88. See also Anne L. McClanan, *Representations of Early Byzantine Empresses: Image and Empire* (New York: Palgrave Macmillan, 2002), esp. 110–11.

25.　Procopius, *Secret History*, 9.18–19 (ed. and trans. Dewing, 108–9); cf. Procopius, *Secret History*, 42 (trans. Kaldellis).

26.　On contraceptives, abortions, and imperial politics, see Betancourt, *Byzantine Intersectionality*, 59–88. See also Évelyne Patlagean, "Birth Control in the Early Byzantine Empire," in *Biology of Man in History*, ed. Robert Forster and Orest Ranum, trans. Elborg Forster and Patricia M. Ranum (Baltimore: Johns Hopkins University Press, 1975), 1–22; Anne L. McClanan, "'Weapons to Probe the Womb': The Material Culture of Abortion and Contraception in the Early Byzantine Period," in *The Material Culture of Sex, Procreation, and Marriage in Premodern Europe*, ed. Anne L. McClanan and Karen Rosoff Encarnación (New York: Palgrave Macmillan, 2002), 33–57; Zubin Misty, *Abortion in the Early Middle Ages, c. 500–900* (Rochester, NY: Boydell & Brewer, 2015); and John Scarborough, "Theodora, Aetius of Amida, and Procopius: Some Possible Connections," *Greek, Roman, and Byzantine Studies* 53 (2013): 742–62.

27.　In its salacious and defamatory treatment of figures and peoples, the *Secret History* is also a tragic preservation of lives often purged from the historical record, as when it recounts Justinian's politically motivated persecution of men suggested to have had sexual relations with other men. Through these screeds of misogyny and homophobia, the text provides evidence for the treatment of people and identities excluded from the official records and only preserved through hatred. See Procopius, *Secret History*, 11.34–36 (ed. and trans. Dewing, 140–41); cf. Procopius, *Secret History*, 55 (trans. Kaldellis).

28.　For a summary of its historiography, see Betancourt, *Byzantine Intersectionality*, 86–88. See Constantinou, "Violence in the Palace," 376–87. See also John M. Riddle, *Contraception and Abortion from the Ancient World to the Renaissance* (Cambridge, MA: Harvard University Press, 1992).

29.　For the entry on Procopius that mentions the *Secret History* by name, see Anonymous, *The Souda*, pi, 2479, ed. and trans. David Whitehead, Suda On Line, https://www.cs.uky.edu/~raphael /sol/sol-html.

30.　Procopius, *Wars*, 22.1–5 (ed. and trans. Dewing, 450–53).

# THE
# SECRETS
# WE
# KEEP

From the relics of the imperial palace to the military uses of Greek fire, some of the most seductive aspects of the Byzantine Empire in the historical imagination have only been partially preserved due to the secrecy that surrounded them. In this book, I wish to examine the role of the art historian in approaching such secrecy, demonstrating how visual evidence allows us to find new answers, but—more importantly—how it can purposely conceal the very realities we seek. How do we access histories preserved only in passing mentions or fragmentary glimpses? How do practices of speculation and reconstruction manifest themselves differently across the work of historians? And what is the ethical import of working with secret histories, beyond military, state, and religious secrets? In other words, how does work on secrecy help us to produce a more robust, more inclusive history of the medieval world? This leads us to ask how secret knowledge is transmitted and how intimacies are edified around collective secret keeping.

Here, I will outline the ways in which secrecy manifests itself in the Byzantine Empire in order to understand the religious, imperial, military, and cultural deployments of secrecy as well as secrecy's function and

conceptualization. I am optimistic that by doing so, in a world overtaken by conspiracy theories that pretend to reveal secrets, we will be better able to see how people have historically crafted stories around the things they do not know or cannot understand, couching conspiracy theories within a framework of fictional speculation rather than in a realm of bombshell truth telling. Such an analysis allows us to critically grapple with how narratives convey a sense of verisimilitude to politically and religiously mobilize audiences. But, more importantly yet, this book is about how we tell stories about secrets as a confrontation with the loss of historical knowledge and about the potent power that storytelling about secrets has on our world, both as sincere historical narratives and bad-faith conspiracy theories.

### DECEIVING APPEARANCES

In early August 944, a high-ranking imperial official by the name of Theophanes rode about eighty-five miles from Constantinople to the Sagaros River to retrieve a mysterious object that had been ransomed to the Byzantine army by the inhabitants of the city of Edessa, another five hundred miles to the southeast. There, Theophanes met the object with a splendid procession, replete with torches and the singing of hymns, and together they made their way back to Constantinople, arriving in the capital on the fifteenth of August, where the object was received by Emperor Romanos I Lekapenos. The object in question here is the Mandylion, a textile upon which Christ's face was miraculously imprinted (fig. 1).[1] According to the legend, King Abgar of Edessa heard of the miracle-working Christ and sent an envoy to Jerusalem to learn more. As the man attempted to draw an image of Christ, he struggled with his awesome form. Christ took pity on the man, so he impressed his face upon a handkerchief to leave behind his image, which was swiftly sent back to Edessa.[2] During the period of Iconoclasm in the eighth and ninth centuries, the Mandylion became a potent validation of Christ's consent to be depicted in images; thus, its importance grew in the imperial and religious programs of the Byzantine Empire.[3]

What was the Mandylion and what function did it play in the post-Iconoclastic Byzantine Empire? In art, the Mandylion is depicted as a splendid textile, displaying the face of Christ in full color and form. In a twelfth-century copy of John Klimakos's *Heavenly Ladder*, the Mandylion is depicted beside the Keramion, a tile that was once placed upon the textile

Betancourt

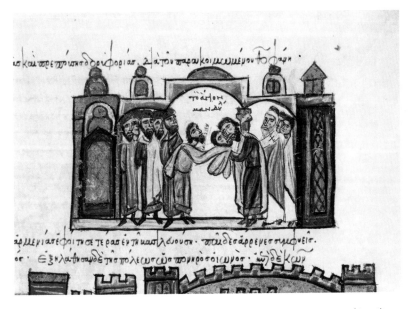

FIGURE 1    Romanos I Lekapenos welcoming the Mandylion into Constantinople (detail).
From John Skylitzes, *Madrid Skylitzes*, twelfth century, Matritensis gr. vitr. 26-2, fol. 131r.
Madrid, Biblioteca Nacional de España.

and miraculously duplicated its image once again (fig. 2). Textile and tile, both brought as spoils of war, would come to be displayed in the Pharos Chapel at the Imperial Palace.[4] However, while the various historical chronicles of the period recount the Mandylion's arrival, none of them provide us with a description of the object. Only one account gives us a suggestion of what this object might have actually looked like: the chronicle of the Pseudo-Symeon Magister tells us that, after the Mandylion's arrival in Constantinople, Emperor Romanos I Lekapenos brought his two sons, along with his son-in-law and co-emperor, Constantine VII Porphyrogennetos, to examine the textile.[5] There, they carefully scrutinized the so-called imprint, but Romanos's sons could see nothing but the vague outline of a face, while the righteous Constantine Porphyrogennetos could make out Christ's eyes and ears. Curiously, this passage is omitted in the other historical accounts of Symeon Logothetes, Theophanes Continuatus, and John Skylitzes, all of which bear similar sources to the Pseudo-Symeon text. It would seem that these versions of the story censored this portion, perhaps because it

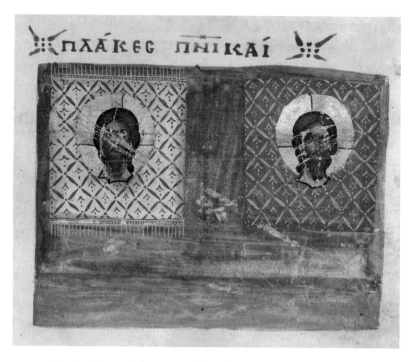

FIGURE 2  The Mandylion and the Keramion (detail).
From John Klimakos, *Heavenly Ladder*, twelfth century, MS Ross. gr. 251, fol. 12v.
Vatican City, Biblioteca Apostolica Vaticana.

appeared to invalidate the claims made by the Iconophiles and the imperial
authorities about the object's veracious depiction of Christ's face in full
color and line.

As various scholars have noted, we hear little of the Mandylion once
it is brought into the imperial storehouses, which contained the most
central relics of Christianity, particularly those of Christ's Passion.[6] While
its representation in art would continue to flourish for centuries to come,
the Mandylion itself was removed from public access, being only processed
once a year during the celebration of the Feast of Orthodoxy. During this
procession, the Mandylion was always kept concealed within its reliquary
box, accessible only to select figures, such as the patriarch, who could
approach and open the box and perceive it through a screen or grates.[7]
Bissera Pentcheva has argued that it was precisely this act of concealment

that heightened the power of the Mandylion as "an object of desire: a sacred energy that was tantalizing within reach yet remained beyond sensual grasp."[8]

Modern scholars have repeatedly come to the conclusion that this fabled object was hardly a figural representation of Christ's face, as it was discussed in the literature, theology, and art of the time, but rather a blank linen textile, perhaps with some smudges that could be read to be suggestive of a face.[9] The omission of the co-emperors' examination of the textile in the historical chronicles, the concealment of the object in its box, and the dissemination of images depicting its fully realized form all suggest the desire of contemporaneous historians to keep secret the true nature of this object. In particular, the popularity of the Mandylion's depiction with Christ's visible face allowed the populace to understand inherently what the textile represented without ever seeing it. Even if one were to question how the miracle of the impression occurred, there was still a sense that by craft or artifice the textile did indeed bear the face of Christ.

The commemoration of the Mandylion also came with its own misdirection, given that in December of the same year as its arrival, Romanos I Lekapenos would be deposed as emperor by his sons and, soon thereafter, Constantine VII Porphyrogennetos would rightly assume his role as sole-emperor.[10] On the anniversary of the Mandylion's arrival the following year, Constantine VII would commission a narration of the textile's recovery that would stage him in a positive light, even presaging his sole-rulership. Interestingly, a wing from a triptych, dated to around 945, now at Saint Catherine's Monastery on Mount Sinai, shows King Abgar receiving the Mandylion (fig. 3). Yet, Abgar's face is that of Constantine VII, as evidenced by a comparison with Constantine VII's portrait in a coronation ivory (fig. 4).[11] Here, we see an imperial program that sought to subsume the acquisition of the textile as either the deed of Constantine himself or as a portent of his rightful place as sole-emperor. Such politics are happenstance in the vicissitudes of imperial programs—and the notion that a reliquary might seek to obfuscate the nature of the relic that it contains can even be seen as a crude stereotype of medieval religiosity.

Across the history and narratives of the Mandylion, historians can appreciate the secrets kept by our textual sources and art, and, at times, the purposeful misdirection that such sources undertake to sustain the imperial and religious programs of the empire. These deceptions emphasize the

FIGURE 3
King Abgar with the Mandylion (top right).
Ca. 945, tempera on wood panel of a triptych, entire panel: 34.5 × 25.2 cm.
Mount Sinai, Saint Catherine's Monastery.

FIGURE 4
Christ crowning Emperor Constantine VII.
945, ivory plaque, 18.6 × 9.5 cm.
Moscow, Pushkin Museum of Fine Arts.

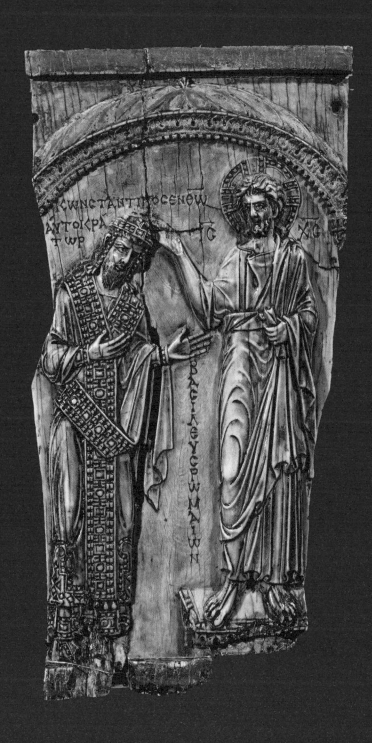

multifaceted task of the historian to work simultaneously with and against our sources, using our most cutting-edge methodologies, techniques, and terminologies to examine the past and to communicate to present audiences, in legible terms, the depth and complexities of history beyond what the sources themselves tell us. The idea that art or our sources "speak for themselves" is a deep misconception. Historical work is not simply a narration of what has occurred but rather a reevaluation of what sources tell us and, often, what they seek to occlude, obfuscate, or change.

### THE POETICS OF SECRECY

Relics such as the Mandylion fully capture the relevance and intersection of the religious, imperial, and military realms of secret keeping. The reliance on containers to both communicate and obscure the relics' identity produces what Seeta Chaganti has called a "poetics of enshrinement," underscoring the absent presence of the relic in the reliquary.[12] This dynamic is one that Jaś Elsner has similarly discussed as being "architectural" in nature, referring to a reliquary as a "kind of building [that] creates a spatial sense of interior and exterior, of barriers to be penetrated, of secrets to be revealed," and it is this tension between secrecy and revelation that articulates the sanctity of the relic.[13] There is perhaps no work of Byzantine art that more eloquently captures the reliquary's innate poetics of secrecy than the object known to us today as the Limburg Staurotheke.[14]

The Limburg Staurotheke is a shallow box made of wood and precious metals, replete with lush enamel images, dedicatory inscriptions, and various relics central to the worship of Christendom. The Limburg Staurotheke depicts on its front the figure of Christ enthroned at the center, sitting upon a richly embroidered cushion and a throne that appears to emulate contemporaneous imperial furnishings, placing him as a parallel to the emperor (fig. 5). Beside him are Saint John the Baptist and Mary (the Theotokos), flanked by the archangels Gabriel and Michael, with rows below and above them containing the twelve apostles. On the back, in hammered,

FIGURE 5  Front of the Limburg Staurotheke.
968–85, enamel and gilded silver, 48 × 35.6 cm.
Limburg an der Lahn, Diözesanmuseum Limburg.

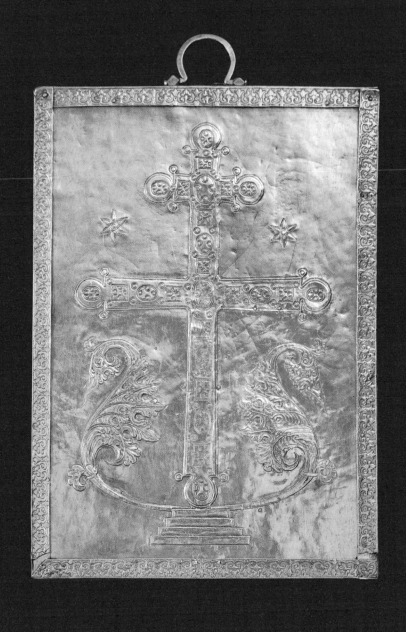

gilded silver, is the motif of the life-giving Cross, with flourishing tendrils sprouting from its base (fig. 6). This Staurotheke (literally, Cross-box) was made to contain the material remains of the True Cross, understood to be the actual wood upon which Christ was crucified.[15]

The inscription running around the border of the box addresses the relic contained within by drawing a parallel between Christ's Crucifixion and the patron's salvation, stating:

*Top:* He did not have beauty, the one hung on wood,

*Right:* But, Christ was complete with beauty; and in dying he did not have form, but he beautified my appearance deformed by sin.

*Left:* Although being God, he suffered in mortal nature; eminently venerating him, Basil the *proedros*, beautified the container of wood,

*Bottom:* on which having been stretched, [Christ] rescued all creation.[16]

While the viewer here looks upon a depiction of the enthroned Christ at the center of the lid, it is only in the act of unlocking the box and sliding up its lid that the relic is revealed (fig. 7). There, one is confronted with the wood of the Cross, which modern technical studies have revealed to be composed of seven individual slivers, arranged into the form of the Cross upon a wooden core. This is the object that we see at the center, surrounded by small doors depicting various heavenly potentialities, such as the cherubim and seraphim, as well as various angels dressed in imperial garb. These protectors guard over the ten additional relics found within this object, each of which is concealed behind the door bearing the name of the relic it contains. The relics include Christ's swaddling cloth and five relics of the

FIGURE 6 **Back of the Limburg Staurotheke.**
968–85, enamel and gilded silver, 48 x 35.6 cm.
Limburg an der Lahn, Diözesanmuseum Limburg.

The Secrets We Keep

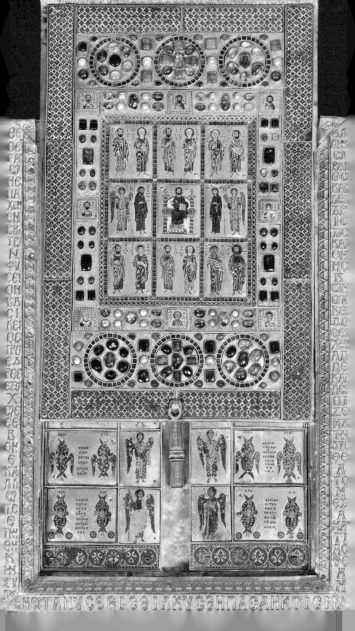

Passion, taken from the Pharos Chapel in the Imperial Palace, comprising the sponge, the crown of thorns, the burial shroud, the towel that washed the feet of the apostles, and the purple cloak of Christ.[17] Three relics are of the Virgin Mary: two are from her girdle (one "from the bishopric of Zela" and the other "from the Church of the Chalkoprateia") and the third is her mantle. Lastly, the box contains a lock of hair from John the Baptist.[18]

The reliquary unfolds once again to reveal what must have been precious fragments taken from these most important relics in all of Christendom that were possessed by the empire. Note that all the objects included in the Staurotheke are ones that could be easily fractioned, speaking to the immense access that its patron, the courtly eunuch Basil Lekapenos, had to the relics and to the permission he was given to cut and splinter these holy things for the construction of the object. As the compartments are opened up, various jeweled windows provide the user of the container a view of the relics contained within (fig. 8). However, the power of the Limburg Staurotheke comes not simply from the holiness of the relics but also from the imperial geography of Constantinople that this object depicts in miniature. In the period of this object's construction, six of these relics can be traced to the Pharos Chapel and one to the Chalke Gate (both within the Imperial Palace complex), two to the Church of the Chalkoprateia, and one to the church at the Blachernai, mapping out some of the most critical monuments of the city's sacred topography (fig. 9).

In the Limburg Staurotheke, we find an object constructed around the tensions of concealment and revelation. Composed of several layers of images, inscriptions, compartments, and relics, the Limburg Staurotheke dramatizes the various levels of access allowed to individual users and audiences. For those fortunate enough to learn its secrets, the reliquary unveils itself through the "poetics of enshrinement," unfurling its meaning over the course of its use as the viewer reads the text, studies its images, and opens its many slots, revealing the once-secret things it contains. In more than one way, this reliquary serves as a conceptual model for us to pry into the visual dimensions of concealment and secret keeping. It provides a

FIGURE 7    Sliding lid of the Limburg Staurotheke with open compartments.
968–85, enamel and gilded silver, 48 × 35.6 cm.
Limburg an der Lahn, Diözesanmuseum Limburg.

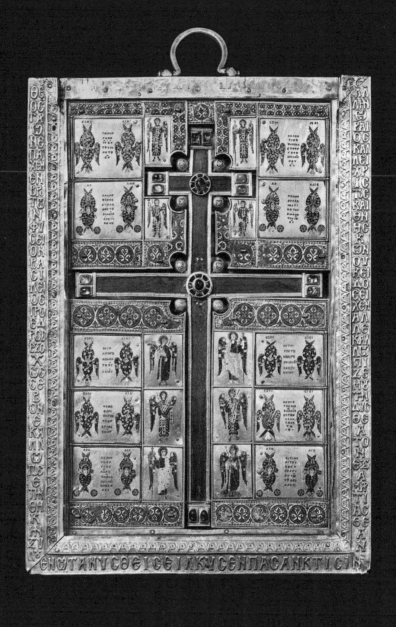

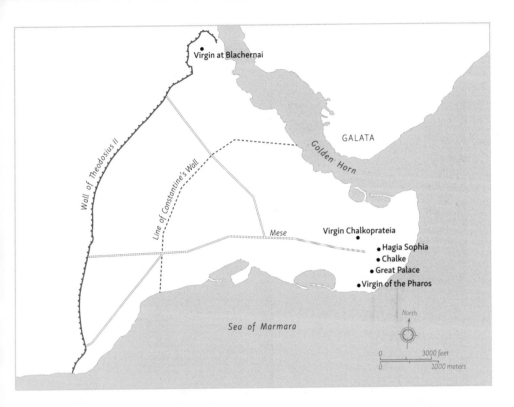

distinctly Byzantine understanding of the poetics of secrecy and revelation, which can guide us as we think through secret keeping more broadly in the empire.

### THE RELIC AS WEAPON OF WAR

Today, in the Diözesanmuseum Limburg in Germany, the display of the Limburg Staurotheke suggests a pious veneration that conceals for modern viewers the reality of the object's creation and use. Set within a glass case, the object is spread open for all to see, and even the small, bottom-right compartment's door is slightly ajar, suggesting access

FIGURE 8    Internal view of the Limburg Staurotheke.
968–85, enamel and gilded silver, 48 x 35.6 cm.
Limburg an der Lahn, Diözesanmuseum Limburg.

FIGURE 9    Map of medieval Constantinople, locating the sites of various relics.

     The Secrets We Keep

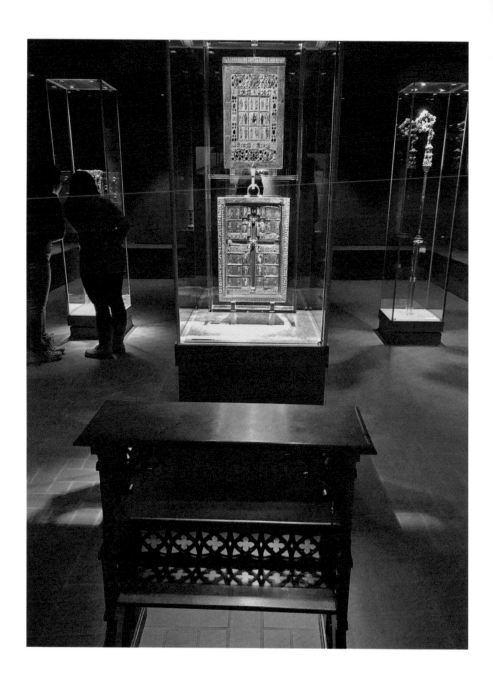

FIGURE 10
Installation view of the Limburg Staurotheke.
Limburg an der Lahn, Diözesanmuseum Limburg.

to its now-lost relics. In front of the case stands a prayer bench, the only one in the room, imputing upon the Staurotheke a distinct sanctity uniquely worthy of veneration in a room filled with other liturgical treasures (fig. 10). Certainly, such focus is due to the only remaining relics in the object: the seven fragments of the wood upon which Christ was hung, formed into the shape of the Cross. And, while the Staurotheke was indeed intended for prayer and veneration, I want to emphasize that inspiring these actions was not the sole or main purpose of this luxury object. As Nancy Patterson Ševčenko has highlighted in her work tracing the relics in this container, if all these relics were kept under the imperial seal, "What then can have been the purpose of the Limburg Staurothek, whose compartments contained mere fragments of, or dust from, these relics, along with a relic of the True Cross? What use could the emperor have possibly had for pocket-sized versions of the relics he already owned?"[19] These are not mere rhetorical questions but ones that point to the unabashed reality of the Staurotheke and its function first and foremost as a weapon of war.

Like the other tactile processes of opening and revelation, the cross of the Limburg Staurotheke can also be taken out from its container (fig. 11). An inscription on the back reveals the object's patrons and purpose:

> On the one hand, God stretched out his hands upon the wood
>
> gushing forth through it the energies of life.
>
> On the other hand, Constantine and Romanos, the despots
>
> with the synthesis of radiant stones and pearls
>
> displayed this same thing full of wonder.
>
> And, formerly, on the one hand, Christ with this, the gates of Hades
>
> smashed, giving new life to the dead.
>
> Now, on the other hand, the crown-wearers having adorned this,
>
> crush with it the temerities of the barbarians.[20]

By stating that Emperors Constantine and Romanos forged it, the cross points us to the reign of Constantine VII Porphyrogennetos and most likely his son, Romanos II, who would become Constantine's co-emperor from 945 to 959. This gives us a secure date range for this internal object, which itself is some years earlier than the container itself, made between 968 and 985 by Basil.

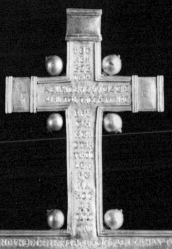

But what is most telling about the inscription is the purpose it states for the cross: after comparing the stretching of Christ upon the Cross to the emperors' embellishment of the cross at hand, the inscription ends by then comparing Christ's smashing of Hades with the emperors' deployment of the object, stating, "the crown-wearers having adorned this, crush with it the temerities of the barbarians." The Limburg Staurotheke was not intended for the private worship of Christ in our contemporary imaginings of medieval Christian piety but as a weapon to be used upon the battlefield.[21]

When Basil Lekapenos, the *proedros*, fashioned the container to include the True Cross reliquary of Constantine and Romanos, along with additional relics some decades later, he did so in his capacity as a high-ranking imperial official. *Proedros* was the title created for him by Emperor Nikephoros II Phokas in 963. This rank was in addition to Basil's already magnanimous title of *parakoimomenos* (literally, the one who sleeps beside the bed [of the emperor]), referring to his role as imperial chamberlain and one of the highest-ranking positions in the empire, reserved for a eunuch like himself.[22] Through the making of the Limburg Staurotheke, Basil extenuates the power dynamics of the empire by producing an object that can enact the imperial power of the capital at a distance through the reliquary. Yet, at the same time, the fracture and facture of relics and reliquary responsible for this patronage also speak to a potent access that reformulates power under Basil's name and reconceals the relics with a new framework offered by this reliquary. It serves as a creative act of concealment that literally reframes the power dynamics of these relics under Basil's name, enabling that power to take on its own effects by proxy on the battlefield.

Thanks to Emperor Nikephoros II Phokas, we also have another True Cross reliquary that attests to the same sentiment of military conquest and use (fig. 12).[23] Made of carved ivory panels and known in the literature as the Cortona Staurotheke, the object proclaims the power of the Cross, stating:

FIGURE 11  **The Limburg Staurotheke's True Cross relic.**
968–85, enamel and gilded silver, reliquary box: 48 x 35 6 cm.
Limburg an der Lahn, Diözesanmuseum Limburg.

The Secrets We Keep

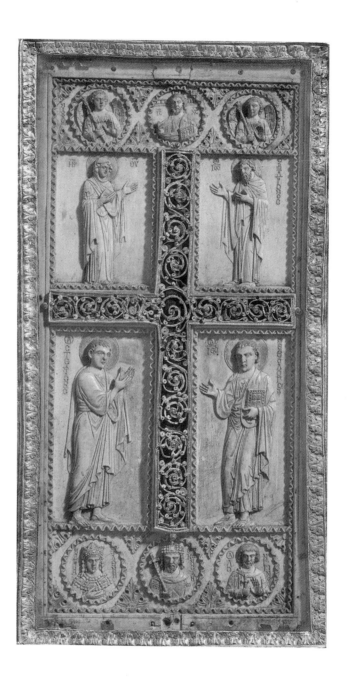

FIGURE 12
**Front of the Cortona Staurotheke.**
963–69, ivory, 30.5 × 14.5 cm.
Cortona, Chiesa di San Francesco.

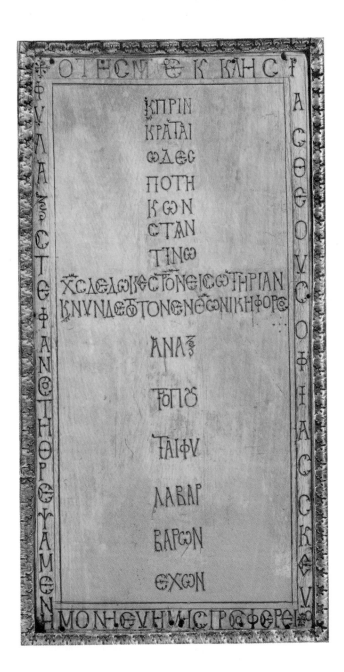

FIGURE 13

**Back of the Cortona Staurotheke.**

963–69, ivory, 30.5 × 14.5 cm.

Cortona, Chiesa di San Francesco.

> Before, to the powerful despot, Constantine,
>
> Christ gave the Cross for salvation
>
> Now, having *this* [i.e., the Cross] the commander in God, Nikephoros,
>
> Puts to flight the groups of barbarians.[24]

As with the Limburg Staurotheke, the inscription suggesting the True Cross's military use is found on the back of the object (fig. 13). Both the Limburg and Cortona inscriptions speak to an added layer of concealment, since the text professing the object's bellicose intentions is offered up only to those privy imperial figures who held and displayed these objects. This experience of the inscription is made palpable through the use of the deictic, demonstrative pronoun "this" (τοῦτον), which refers not only to the Cross given for salvation but also to "this" very object that the person reading the inscription is holding in their hands.[25] There is a sense of intimacy here with how this object presents itself to users, depending on their level of access and proximity to its physical dimensions.

In the inscription's cruciform construction, the first and final verses take up the most space, consisting of the top and bottom sections of the cross. Thus, the inscription places visual emphasis on the power of Constantine the Great above and Nikephoros defeating the barbarians below. While in the Limburg Staurotheke this dynamic of past and present is structured as between the historic deeds of Christ and the current deeds of the emperors, in the Cortona Staurotheke that past/present is structured alongside the history of the empire, drawing the connection between Christ giving Constantine the relic of the True Cross and Nikephoros's military victories now.[26] Fruitfully, the use of the name Constantine in the mid-to-late tenth century must have also brought to mind the recent empire of Nikephoros's near predecessor Constantine VII and the imperial objects and relics, like the Limburg Staurotheke's True Cross for whom it was fashioned. In other words, this dedication is as much a contemplation of Christ's command as it is a manifestation of the empire's power in the possession, arrangement, and deployment of these relics, often through conquest and war. The language used in the final verse has strong military undertones; the words *Lord* (ἄναξ), *puts to flight* (τροποῦται), and *groups* (φῦλα) suggest a military commander, a victory or "turn" in the tide of war, and a military subdivision, respectively.

Betancourt

As mentioned earlier, the relics in the Limburg Staurotheke did not simply emerge in Constantinople but rather were understood to have been taken by imperial forces from across the region over the course of centuries of military campaigns, just as we saw with the Mandylion. Some of these relics had even been brought by the empire quite recently and thus bore the knowledge of recent military triumphs. For instance, the second piece of the Virgin's girdle was brought by Constantine VII and Romanos in 942, and the hair of John the Baptist was taken from Syria either in 968 by Nikephoros II Phokas or in 975 by John I Tzimiskes, depending on the source.[27] Even the wood of the True Cross would have been associated with its discovery in Jerusalem and transfer to Constantinople by Constantine the Great and his mother Helena. Thus, these types of reliquaries were both a map of the ecclesiastical topography of the city and its relics and, just as importantly, a map of the conquests of empire, with each relic bearing the knowledge of its provenance and the Byzantine military successes that brought them to the city.

### RELICS ON THE BATTLEFIELD

Surprising as it might be to modern readers, objects like these—especially relics of the True Cross—were known to have been carried into battle, precisely as offensive weapons.[28] Since late antiquity, sources have told us how relics were deployed in battle: Constantine the Great was said to have placed relics of the Cross in his armor, and liturgies on the battlefield deployed reliquaries, crosses, and liturgical manuscripts, as various military treatises and historical accounts can attest.[29]

In one military treatise, compiled at the behest of Constantine VII Porphyrogennetos, the text outlines the movements of troops and officers on the battlefield, noting how the *koubikoularios* (one of the eunuch chamberlains) carried "the holy and life-giving wood of the Cross, with the case about his neck."[30] Note the large loop at the top of the Limburg Staurotheke, which allows for this object to be hung, potentially upon the neck of a high-ranking eunuch (see fig. 5). Relics were understood by the Byzantines as being "receptacles of divine energies" (θείας ἐνεργείας . . . δοχεῖα), as stated by John of Damascus, and these energies could be mobilized by human intervention.[31] Nothing makes the utility of such relics more evident than one military speech, given by Constantine VII Porphyrogennetos in 958, as the army left to fight the Ḥamdānids. There, he states that a "holy oil"

(ἀπομυρίσαντες), also described as a "blessing" (ἁγίασμα), has been drawn from the relics of the Passion, among others. This oil, he says, is being sent alongside the troops "to be sprinkled upon you, for you to be anointed by it and to garb yourself with the divine power from on high."[32]

The very format of the Staurotheke speaks not only to its salvific powers but also to its function as a curative tool. These box reliquaries have their predecessors in late antique medical and surgical boxes: small portable containers used to carry various medicinal substances by doctors and surgeons, as seen in a sixth-century ivory medicine box from Dumbarton Oaks, which depicts the goddess of healing, Hygieia (fig. 14). Other examples include a medical kit in the British Museum dating to the first or second century that features variously sized compartments and a sliding lid (fig. 15); and a spectacularly adorned medical box at the Neues Museum, from the same period, with a silver-and-niello image of Asclepius, the god of healing, standing upon steps and framed by columns and a pediment with animals (fig. 16).[33] These medical implements bear a striking resemblance to the design of the Limburg Staurotheke with its sliding enameled lid and doored compartments. This resemblance, as Cynthia Hahn points out, stressed the understanding of relics as having a medicinal, healing capacity.[34] But, furthermore, it speaks to a form of object associated with the specialized know-how of surgeons and doctors. Both the Staurotheke and the medicine box are active tools of human intervention, primarily ones that would have worked together on the battlefield for the defeat of the enemy and the treatment of the injured troops. For example, the military treatise by Constantine VII notes precisely the inclusion in the imperial baggage train of "receptacles with all kinds of oils and remedies; and diverse salves and unguents and ointments and other medical substances, herbs and whatever else is necessary for the curing of men and beasts."[35] This is in addition to the relic of the True Cross mentioned elsewhere in the same text, as discussed above.

FIGURE 14   **Medicine box with Hygieia.**
Sixth century, ivory, 7.5 × 6.0 × 2.5 cm.
Washington, DC, Dumbarton Oaks Research Library and Collection.

FIGURE 15   **Roman medicine box.**
First to second century, bronze, L: 13.6 cm.
London, British Museum.

Betancourt

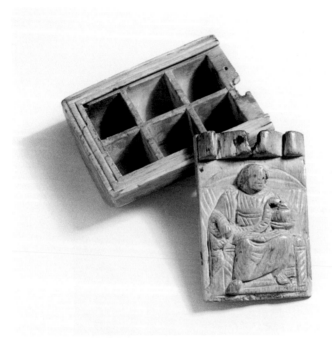

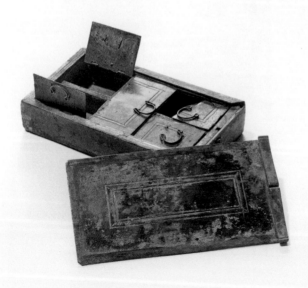

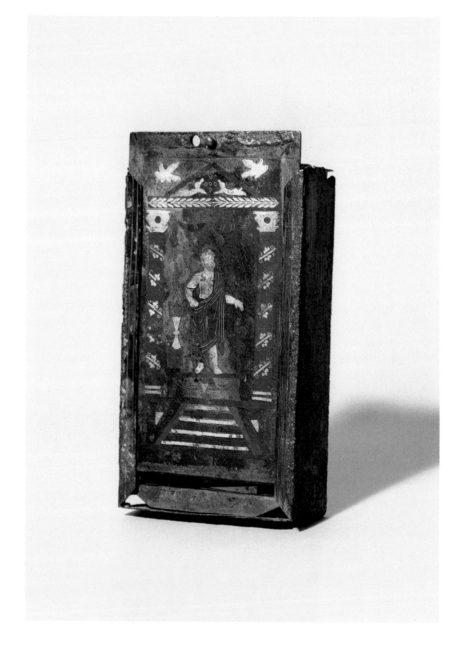

FIGURE 16
**Roman medicine box with Asclepius on the lid.**
First century, paint, silver, niello inlay on bronze, 11.6 × 6.8 cm.
Berlin, Antikensammlung, Staatliche Museen zu Berlin.

Smaller, more personal reliquaries intended for the battlefield similarly articulated pleas for protection and victory by their users, as in the reliquary pendant of Saint Demetrios with the figure of another military saint, Saint George (fig. 17).[36] Here, the reliquary proclaims: "Being anointed by your blood and *myron*, [the wearer] supplicates you to be his fervent guardian in battles."[37] The *myron* is a sweet-smelling oil reminiscent of the oil drawn from the Passion relics for the Byzantine army in Constantine VII's speech. Just like the Staurotheke, the reliquary pendant is staged as an explicitly military object and derives its efficacy through the processes of concealment and revelation. To commune with the relic (which here is comprised of some tincture of myron-soaked earth), users must open up the clasp to first confront the enameled image of a recumbent Saint Demetrios in the space of his tomb in Thessaloniki (fig. 18). Then they can carefully open that enameled panel, which serves as a door, to reveal a metal-relief articulation of the saint's body (fig. 19). By having users move from the two-dimensional enamel to the three-dimensional relief of Saint Demetrios's body, this intimate object dramatizes the pageantry of unveiling and approaching the saint's myron.

In this case, the myron was an oil that gushed forth from the nonexistent relics of Saint Demetrios. While tradition held that the saint's body was somewhere on the site of the church of Saint Demetrios in Thessaloniki, attempts to find it had always failed, having been miraculously stopped by the saint to keep his body there (presumably), eventually giving way to the discovery of this fragrant oil in the soil. From the tenth or eleventh century, the myron began to flow into the crypt of the church and was brought up to the saint's empty tomb, where pilgrims collected it in lead ampullae.[38] In an account from the thirteenth century, contemporaneous with the pendant reliquary, John Staurakios, a church official, recounts how the myron flowed from pipes underneath the church, filling cisterns in the nave of the church where the focal point of the cult was located.[39] The flow of the myron even seemed to increase according to demand, as on the feast day of the saint, when it flowed more copiously, as another source tells us.[40] This myron offered an endless supply of relic-like matter to be distributed and consumed by the faithful. Practices such as these had a long-standing

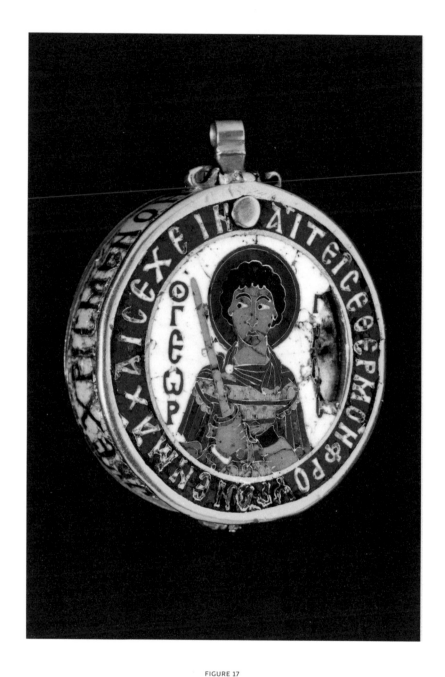

FIGURE 17
Saint George on the back of reliquary pendant of Saint Demetrios
(front medallion of Saint Demetrios is missing).
Eleventh century, gold and enamel, H: 46 mm, Thickness: 10.5 mm, Diam.: 37 mm.
London, British Museum.

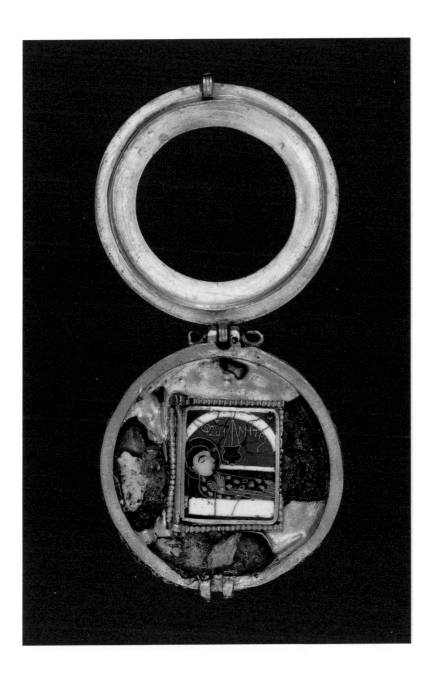

FIGURE 18
**Interior of reliquary pendant of Saint Demetrios.**
Eleventh century, gold and enamel, H: 46 mm, Thickness: 10.5 mm, Diam.: 37 mm.
London, British Museum.

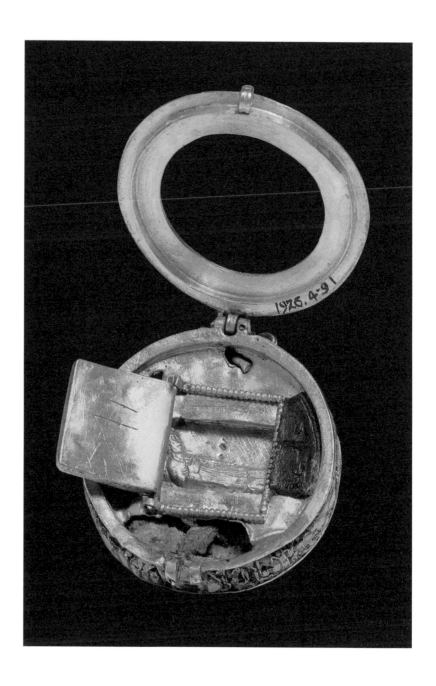

FIGURE 19

**Reliquary pendant of Saint Demetrios, opened.**

Eleventh century, gold and enamel, H: 46 mm, Thickness: 10.5 mm, Diam.: 37 mm.

London, British Museum.

history in the Byzantine world. For instance, the mid-sixth-century account of the Piacenza pilgrim describes how ampullae, filled with oil, were pressed against the True Cross at the Holy Sepulcher, causing the oil in the flasks to instantly bubble and overflow.[41]

These accounts inevitably lead us to speculate on the nature of these miracles and the secrets kept about their facture. As Christopher Walter, in his study on warrior saints, muses: "To what extent the flow of his [Demetrius's] *myron,* which descended through pipes into basins in the refurbished *hagiasma,* was miraculous and to what extent the phenomenon was facilitated by human intervention cannot be determined."[42] In all likelihood, the myron that flowed from the tomb of Demetrios was more like the oil drawn from the relics of the Passion for Constantine VII's army or like that oil pressed against the True Cross at the Holy Sepulcher. That is, the oil did not miraculously ooze out of the hallowed remains; rather, it was poured into contact with this holy site and by virtue of this association was deemed efficacious. And, furthering the linkage to human intervention, it is certainly well attested that oil, often described as fragrant to indicate its sanctity, was the preferred medium for mass-producing a substance akin to the relic.[43] By the fifteenth century, ongoing concerns about the forgery of such miracles would lead the imperial official and theologian Demetrios Chrysoloras to rebuke the suspicions about the facture of the myron, arguing that it was "not like some other artificial [σκευαστῶν] substance."[44] These concerns were already inherent in John Staurakios's account, aimed at arguing against the concoction of the myron.[45] Both authors express a similar anxiety about its purported artificiality, with the same use of the term *skeuastos* to indicate a work of human artistry.

### FORGING THE SACRED

Anxieties about the nature of relics were certainly expressed by medieval writers, a phenomenon well documented by Patrick Geary in his studies on the theft of relics in the Western European Middle Ages.[46] In the Byzantine world, however, one of the more lucid texts on the relic market and its forgeries comes down to us from the mid-eleventh-century poet Christopher of Myteline, who in one of his texts ridicules a monk in Constantinople by the name of Andrew for his gullible belief in relics.[47]

In this staunchly satirical poem, Christopher repeatedly praises Andrew for his inimitable "faith" (πίστις), which has allowed him to believe that he possesses five breasts of Saint Barbara and four heads of Saint George, writing, "So fervent, Andrew, is your faith, persuading you God's champions were Hydras, and making female martyrs seem like wild dogs, the former possessing thousands of heads, the latter with a multitude of breasts, like female dogs."[48]

Christopher lists a litany of relics that Andrew collected thanks to his extraordinary faith, the punchline of the joke being that all these relics come from figures whose bodies either departed this earth intact, like Enoch and Elijah, or who are incorporeal entities, like the angels and cherubim. Christopher's vignettes even shed light on the practices and techniques of forgery; at one point, he describes how a con man took the bone of a sheep and "painted it all over with saffron dye, scented it with incense, wrapped it up," and then sold it to Andrew, claiming it to be the bone of a martyr.[49] Here, we see how an aged appearance and a sweet-smelling fragrance might be uncritically taken as self-presenting markers of sanctity.

Curiously, in Christopher's poem, the "true" relic per se is nowhere to be found. There is no foil or counterexample that seeks to demonstrate that Andrew has erred or committed blasphemy in his stupidity. Instead, it is faith alone that receives the ire of the poet, as he casts a disparaging light on the relics of Constantinople without ever being so bold as to speak of any specifically. One is left to wonder, for instance, how Christopher viewed the girdle of the Virgin in the Limburg Staurotheke, which existed in two different versions in the same church, brought from two different places, and which was allegedly believed to be one and the same object. While Christopher's poem presents a satirical extreme to the questions of deceit and veracity that surround relics, his interrogation brings us to the core of what animates my interest in secrecy here: that indeterminate space between deceit and good-faith action.

### THE INTERSTICES OF SECRET KEEPING
When Constantine VII informs his troops that an oil (ἀπομυρίσαντες) was drawn from the relics and a mixture created from the oil that could be sprinkled upon (ῥαντισθῆναι) them to anoint

(περιχρισθῆναι) them for battle, clothing the troops in "divine power" (θείαν ... δύναμιν), the emperor is describing in good faith a process for producing oil that might have certainly been the same, through pipes and cisterns, for Saint Demetrios. What Constantine VII's military oration makes clear is that even the relic—that object deemed to be contiguous with the very matter of saints in some capacity—could be forged in proxy by human intervention, in this case through the production of an oil sanctified by contact. While the sources on Saint Demetrios are more taciturn about this human intervention than Constantine VII's words (perhaps due to the absence of a concrete body or relic), the logic and process still seem to be in accord with other long-standing practices for the human production of relics—what might appear to us as a contradictory statement.

It is in these interstices that secret keeping becomes a pertinent concept for examining (and speculating upon) how we approach these historical paradoxes. Secrecy is not the same thing as deceit—it is not a lie by omission. In fact, as we have seen here thus far, the experience of divine presence and contact with the saintly is precisely articulated through the pageantry and successive unfurling of good-faith secrecy, embodied by objects like reliquaries. Upon opening up the Limburg Staurotheke, the viewer moves from an iconic depiction of Christ, Mary, and Saint John the Baptist that readily gives way to a feeling of presence when one confronts the individually concealed fragments of objects that once touched them. That presence, although highly qualified, is nevertheless one that seemed impossible when the viewer first began to unbox the object with its more common and expected depiction of these figures on its cover.

As an object of war, this reliquary also existed in the most intimate spaces of the imperial entourage, meaning the troops could have only experienced and been galvanized by it at a distance. In its ability, for example, to perhaps produce on the battlefield an oily-relic tincture for the troops, the reliquary manifests its power through proxy and (certainly) through obfuscation of the mechanics of what this act of oil-drawing might have looked like. The intimate and elite process of this oil-drawing emphasized who was within the inner circle of the emperor and his chamberlains. Furthermore, it bound together these select few who had intimate access to the reliquary and knowledge of the tincture's production, details that a military leader might not necessarily wish to express in full to his troops.

The Secrets We Keep

The troops themselves were instead bound by the mystical powers of this secret substance when it was rained down upon them in a communal act of military unity and divine validation by the emperor.

### AUTOMATA AND ENCHANTMENT

To push the questions about the role of secrecy and secret keeping further, let us move toward one of the more intriguing elements of the Byzantine court: the automata of the throne room.[50] On 7 September 949, Liutprand of Cremona, a diplomat sent by King Berengar II of Italy, arrived in Constantinople. In his travelogue, Liutprand recounts the wonder-inspiring way in which he and his entourage were received in the Great Palace of Constantine VII Porphyrogennetos. Upon entering the reception hall of the Magnaura, Liutprand is confronted with what was for him an expected sight, which he describes in astounded detail:

> In front of the emperor's throne there stood a certain tree of gilt bronze, whose branches, similarly gilt bronze, were filled with birds of different sizes, which emitted the songs of the different birds corresponding to their species. The throne of the emperor was built with skill in such a way that at one instant it was low, then higher, and quickly it appeared most lofty; and lions of immense size (though it was unclear if they were of wood or brass, they certainly were coated with gold) seemed to guard him, and, striking the ground with their tails, they emitted a roar with mouths open and tongues flickering. Leaning on the shoulders of two eunuchs, I was led into this space, before the emperor's presence. And when, upon my entry, the lions emitted their roar and the birds called out, each according to its species, I was not filled with special fear or admiration, since I had been told about all these things by one of those who knew them well. Thus, prostrated for a third time in adoration before the emperor, I lifted my head, and the person whom earlier I had seen sitting elevated to a modest degree above the ground, I suddenly spied wearing different clothes and sitting almost level with the ceiling of the mansion. I could not understand how he did this, unless perchance he was

lifted up there by a pulley of the kind by which tree trunks are lifted.[51]

The automata of Great Palace's throne room are today shrouded in secrecy due to their total disappearance and to the startling realities that this text recounts, though we should have no reason to doubt Liutprand's account.[52]

What is most pressing about Liutprand's account here is the way that this upstart diplomat approached the reception, stating that when the lions and birds began to call out, "I was not filled with special fear or admiration, since I had been told about all these things by one of those who knew them well." It would seem then that Liutprand undid the surprise—the fear and admiration that the performance might have stirred up—by penetrating the veil of secrecy surrounding the reception hall and by being prepared in advance so as to not show any surprise. Yet, when he raises his eyes to find the emperor floating above him, Liutprand confesses that he "could not understand how [the emperor] did this, unless perchance he was lifted up there by a pulley of the kind by which tree trunks are lifted."

While it might be suggested that Liutprand provides a plausible explanation here to downplay the impressiveness of the scene, his confusion and speculation instead remind us of the role of wonder and wonderment when people come upon secret things. To reference Alfred Gell's dictum about the technology of enchantment and the enchantment of technology: technology can certainly be used to enchant audiences, but technology *qua* technology can also be enchanting.[53] When confronted with a toothpick model of a cathedral (inside said cathedral), Gell muses more about his childish enchantment with the model than about the building itself, reasoning that his visceral and familiar knowledge of a toothpick allowed him to better marvel at the labor required to build the model than at the more abstract and removed realities of medieval building technologies and masonry.[54] It would appear that enchantment is fueled precisely by the balanced state of marveling—on the cusp between concealment and revelation, between familiarity and unknowing.

In the mid-twelfth century, a fictional account of the automata of Constantinople would feature prominently in *Le voyage de Charlemagne*, a Western medieval historical romance depicting the travels of Charlemagne and his entourage.[55] In Constantinople, the group encounters fantastical, large-scale iterations of the throne-room automata, such as a spinning

palace and various musical figures. Marveling at the mysteries of this technology, Charlemagne and his retinue reason that the palace "had been made by *cumpas* and noble secrets."[56] In other words, the author stages the automata as a product of the intractable and concealed "noble secrets" (*serét noblement*) combined with the esoteric yet knowable art of *cumpas*, an astronomical science dedicated to calculations of time.[57] This tension between knowing and unknowing enlivens the fascination with the animation of the inanimate, sometimes abstractly defined (as in the astral sciences) and sometimes concretely visceral (as in the case of Gell's toothpick).

### UNKNOWING AS A METHOD

It is the state of unknowing that sutures the double bind of not knowing how the myron is made while still allowing for a miraculous and a mundane cause of its origin to coexist; the state of unknowing also captures how the emperors Romanos I and Constantine VII might gaze upon the smudges of the Mandylion and struggle to see a form yet still herald its veracious impression of Christ's face. Is there a secret there that is purposely trying to deceive? For example, that the Mandylion depicted nothing and it was all an imperial lie? That the miracles of relics were actually forged lies to appease a public delightfully willing to be enchanted by the miraculous? Perhaps, and arguably the latter possibility is the most likely case. As a historian, however, I have no evidence to articulate such an argument, despite how feasible it might be—and how unfeasible the alternative is. Instead, what we can perceive in our sources is a testament to these states of unknowing, with those sources depicting, for instance, the object before the emperor as the Mandylion while the emperor, in good faith, studies its inchoate marks, seemingly urging Christ's form to reveal itself from the formlessness. These accounts capture methods of inquiry into that which is concealed, providing historical methodologies of analysis about how to approach the things left as secrets of the natural, divine, and imperial worlds.

Such methods of unknowing may seem too erudite for their common application, but in fact, it is precisely under these terms that a tenth-century Byzantine military treatise on siegecraft introduces the subject at hand, acknowledging that "everything about siege machines is difficult and hard to understand, either because of the difficulty of comprehending the concepts, or, to say it better, because of their

incomprehensibility to most men; perhaps they are comprehensible only through 'unknowing' [ἀγνωσίᾳ]."[58] For the military historian Denis Sullivan, this turn of phrase derives from Pseudo-Dionysios. Sullivan calls the phrase a "negative cognition" that rejects the senses of the perceptible world in order to know what is beyond. As Pseudo-Dionysios writes, "through unseeing and unknowing to see and know what is beyond seeing and knowing."[59] In the West, this thinking leads to an apophatic theology, one that acknowledges the imperceptibility and incomprehensibility of the divine, which therefore can only be negatively defined. Yet, here, in a military treatise of all places, it serves as a methodology for a tenth-century reader to be able to navigate through the difficulties and obscurities of a text that compiles for them the writings of ancient and late-antique authors on siege warfare. Thus, unknowing becomes a fundamental state of relating to the aporia of historical knowledge and the gaps lost to history while still being able to comprehend its lessons and concepts.

Just a century later, the court philosopher Michael Psellos would articulate a similar argument when referring to the learning and possession of the so-called occult sciences, which encompassed everything from alchemy, astrology, and prognostication to the natural sciences. In a letter to a friend about the learning of these sciences, Psellos writes regarding such matters:

> These things are secret to many and wholly unknowable. But, to me . . . nothing unspoken is unknown through the all-searching curiosity of my soul. And I have collected the methods of all of them, but I have not used any of the secret practices. Instead, I swear off their users, taking from these men only enough to be able to learn about some of the occurrences whose functioning seems inexplicable to most people.[60]

Here, we see another formulation of unknowing as a method for accessing secrecy, variably defined by Psellos as that which is "unspeakable" (ἄρρητος) and that which is "hidden/forbidden" (ἀπόρρητος).[61]

For the learned Psellos, nothing is out of reach, though his knowledge is tempered in order to avoid partaking (allegedly) in forbidden practices. Here, the aporia of his learning, the gaps in his knowledge, are purposeful:

they limit his ability to use this knowledge while still enabling him to achieve an understanding of the overall concepts, which would seem mystifying to others. In the earlier military manual, the gaps in knowledge are crossed over by the harnessing of unknowing, allowing a similar (albeit partial) grasp of the material that nevertheless presents a feasible picture of the information, viewing that as a way of mobilizing this partial knowledge. While achieving different aims, both the philosopher and the military author embrace unknowing as an epistemological practice to confront the secrets lost to history and ancient learning.

More broadly, unknowing can define the broader relationship between a subject of the empire and all those elements of imperial rule (statecraft, military, and religion) that are purposely obscured, concealed, difficult to comprehend, or part of the natural world under the empire's dominion. Here is where the state of marveling—between familiarity and unknowing—is shown as crucial to empire: philosophical, religious, and military secrets encourage marveling and ultimately sustain political structures of power. This marveling or wonderment has been well documented in the previous pages through literary texts, historical chronicles, tactical treatises, and works of art aimed at confronting their readers and viewers with various aspects of imperial life that are restricted to an elite. Marveling is not a willful state of ignorance but a suspension of knowledge, with subjects understanding its limitations and absences without allowing that to impede their operation in the world. In considering the processes of a medieval subject formation, unknowing becomes an apt Byzantine concept for articulating the relationship to the secret worlds of empire, making them legible and comprehensible through obliqueness and fragmentation.

### GREEK FIRE AND STATE SECRETS

Perhaps the most illustrious secret of the Byzantine Empire is its use of a weapon most commonly known today as Greek fire (*ignis graecus*), as described by Western onlookers including Liutprand of Cremona.[62] The Byzantines themselves, however, referred to it using a host of different terms, including *liquid fire* (ὑγρὸν πῦρ) and *sea fire* (θαλάσσιον πῦρ). They also described the substance as "artificial" (ἐσκευασμενένον/ σκευαστόν) or "sticky" (κολυτικὸν) fire and popularly called it "brilliant" (λαμπρόν).[63] Often synonymous with the Byzantine navy and the *dromon*, a type of warship, this fire was shot out like a flamethrower and was feared

for its ability to burn on water. Professional and amateur historians have long debated, speculated about, and mused upon the potential composition of the mixture, even undertaking a series of reconstructive experiments. What is certain is that Greek fire was some sort of petroleum-based incendiary, related to naphtha, that was heated and then ignited as it was discharged from siphons.[64]

Representations of Greek fire are rare in the art historical record. A unique example occurs in the *Madrid Skylitzes*, where the Sicilian illuminators of this Byzantine historical chronicle have shown a battleship spewing the liquid fire onto an engulfed enemy ship (fig. 20). The Byzantines use siphons here, as the military treatise tells us was customary to deploy the ignited liquid, and these siphons are even gilded to show their likely composition from copper or some other luminous metal. A depiction in one of the military treatises discussed earlier shows a soldier climbing a ladder and using a "handheld siphon" (ἐγχειριδίων πυροβόλων) as a flamethrower as the soldier approaches an enemy fortification (fig. 21). The military treatise here suggests that the purpose of this handheld incendiary is not to destroy the wall, as seen in the case of naval battles, but rather to "terrify [the enemies] standing on the front of the wall so that they quickly abandon their position."[65]

Throughout key Byzantine military treatises and historical chronicles, we witness the repeated appearance of Greek fire and its various siphons to destroy or simply terrify enemy armies. Yet, for our purposes here, the lengthy debate on the composition and appearance of this weapon is less relevant than the fact that from the tenth through twelfth centuries, Byzantine imperial authorities concertedly understood this weapon in terms of tightly guarded state secrets.

In the tenth-century *On the Governance of Empire*, composed by Constantine VII for his son Romanos II, we find Greek fire categorized under secrets of the state. Constantine VII warns his son that many nearby enemies and competitors will ask, for example, for the imperial vestiture and diadems, which must never be handed over. The reasoning is that these "were not fashioned by men, nor by human arts devised or elaborated."[66] Here, the same language that we witnessed to clarify the miraculous origin of Saint Demetrios's myron is deployed for the imperial garments and crowns, which are clearly described as not having been made by human "artifice" (κατασκευάσθησαν). Constantine VII traces this understanding

FIGURE 20 **Byzantine army using Greek fire against an enemy ship (detail).**
From John Skylitzes, *Madrid Skylitzes*, twelfth century, Matritensis gr. vitr. 26-2, fol. 34v.
Madrid, Biblioteca Nacional de España.

of the imperial regalia back to Constantine the Great, saying that it is "as we find it written in secret stories of old history."[67] These secret stories (ἀπορρήτοις λόγοις) suggest that it is not only the possession of these garments that is restricted but also the knowledge of their origin and miraculous facture.

Constantine VII then turns to the matter of the liquid fire (ὑγροῦ πυρός) that is discharged through tubes, which God revealed to Constantine the Great through an angel.[68] The emperor proceeds to recount how liquid fire should only be manufactured within the empire, by Christians, and never taught to any other group or manufactured elsewhere. Curses, he tells his son, have been inscribed in the altar of the Hagia Sophia in Constantinople to ensure that any emperor or imperial official who betrays these commands be swiftly and most cruelly be put to death. At that point, Constantine VII describes how a military governor once betrayed this

συρο σμιχ ετωοφε ρομ τ ρ με. ταχ1ομαυτο ς
ς χ δς τ τό πού. ς ταυχ μ κα ι γ ρ απτι αι: —

FIGURE 21   Soldier using handheld siphon for Greek fire (detail).
From Heron of Byzantium, *Parangelmata Poliorcetica*, eleventh century, gr. 1605, fol. 36r.
Vatican City, Biblioteca Apostolica Vaticana.

command and, upon entering the church, was consumed by a fireball from heaven.[69]

In addition to providing this frightening warning to his son, Constantine VII also transmits critical secrets of the state to him here, outlining in the treatise the various sites in which naphtha can sourced from wells across the Pontic and Caucasus regions, placing a great deal of emphasis on the distance of these wells from the sea and on how to subjugate the peoples of these regions, if necessary.[70] Knowing that crude oil would have been a critical resource for the production of Greek fire, the transmission of this knowledge has been intriguingly pertinent to military historians, despite there being no clearly articulated connection between Greek fire and naphtha in the text.[71] In the first-century text of Dioscurides's *De materia medica*, naphtha is introduced in the section on asphalts, noting that it "has the power to readily catch fire so as to grab it

The Secrets We Keep

+ ἄΣΦΑΛΤΟΣ
ΠΙΣΣΑ :–

ἀσφαλτος πίσσα· τὸ νἀναζαρβέως :–

[Greek minuscule text, largely illegible]

ἄΣΦΑΛΤΟΣ
ΒΑΒΥΛΩΝΙ
ΟΣ :–

ἀσφαλτος βαβυλώνιος   τὸ νἀναζαρβέως :–

[Greek minuscule text, largely illegible]

FIGURE 22

Manual showing examples of naphtha and other asphalts.

From Dioscurides, *De materia medica*, mid-tenth century, MS M.652, fol. 223r.
New York, Morgan Library & Museum.

from a distance."[72] The contemporaneous tenth-century illuminated copy of the Dioscurides manuscript at the Morgan Library features various depictions of different types of asphalt, the highly viscous form of petroleum, paying discerning attention to their various colors and uses (fig. 22).

### SECRET KEEPING AND COMMUNITY

In the treatise for his son, Constantine VII also tells an alternative story about the origin of the liquid fire, similarly dated to the reign of Constantine the Great but attributed to a certain Kallinikos, who, fleeing from Heliopolis, went to the Byzantines and manufactured for them the liquid fire.[73] In his eleventh-century historical compendium, George Kedrenos recounts this iteration of the story, noting that a master builder (ἀρχιτέκτων) from Heliopolis in Egypt discovered sea fire (τὸ θαλάσσιον πῦρ) and brought it to the Byzantines.[74] Then, he goes on to say that "from this man is descended the lineage of Lampros, who still today skillfully prepares [κατασκευάζοντος] the fire."[75] It is generally understood that the Lampros family is fictive, given that a common term for Greek fire, brilliant (λαμπρόν), matches the name Lampros. And, similarly, the name Kallinikos—which means "beautifully victorious" (καλλίνικος)—also relates to a larger theme that serves to underscore the power of liquid fire. While these names appear to have been made up for their symbolic power, they emphasize that in the tenth through eleventh centuries there was a heightened understanding in the textual evidence of Greek fire being transmitted and preserved through closely knit networks of secrecy, either through the imperial lineage of Constantine VII or through the lineage of Kallinikos and the Lampros family.

In considering the history of Greek fire, Alex Roland has emphasized the uncodified transmission of this technology through secrecy, with the knowledge of Greek fire's craft and artifice limited to elite imperial networks.[76] This handing down of craft knowledge and its intersections with secrecy, the "occult," and other forms of esoteric knowledge have been well explored by scholars in the history of technology, like Pamela O. Long, underscoring the ways in which premodern learning has been transmitted.[77] As Shannon Steiner has recently argued, beginning in the ninth century, Byzantine artists perfected the process of cloisonné enameling, where powdered, colored glass is poured into miniature compartments made of a fine filigree of metal wires and fused under high heat.[78] This craft

The Secrets We Keep

was categorized under the alchemical sciences, and the recipes for various glass compositions were transmitted in the broader alchemical corpus. As Steiner demonstrates, cloisonné enameling served as an ostentatious display of the technical virtuosity transmitted through the restricted knowledge of the craftsperson working in this rarified skill—akin to a trade secret. In other words, these processes of secrecy and knowledge transmission, as sensational as they might appear in the context of Greek fire, are no less rarified and esoteric than the forms of artistic knowledge that allowed for the enamelists to create the luminous images on the Limburg Staurotheke, made from the cutting-edge developments in cloisonné enamel.

Ultimately, secrecy and secret keeping are acutely disruptive by virtue of the act of revelation, whether what is revealed is technical virtuosity or a terrifying power. Yet, the act of mutual concealment also generates powerful intimacies, as it can contour the lines of imperial families or even imagine the mythic origins of a technology, passed down through a single lineage. Secret keeping is a nourishing kindling for the generation of chosen families as well.[79] Benjamin Saltzman has deftly explored the bounds that secrecy produced in the context of monastic groups in medieval England, with the groups negotiating between the concealment of knowledge from fellow humans and the confrontation with God's inescapable omniscience.[80] In this context, secrecy leads to what Saltzman calls the "culture of scrutiny," which "depended on and fostered the idea that secrets could be forced open at any time by divine intervention."[81] It is the practice of this precarity that negotiated the human and divine dimension of secrecy.

In this text, secrecy has been staged as between imperial power and its subjects. At times, it would even seem that both the mortal and the divine are subjected to the empire's power, and that the poetics of concealment and revelation structure modes of experiencing elite power that meaningfully blur the boundaries between knowing and unknowing, belief and deceit, good and bad faith. Through the negotiation of these boundaries, of double-bind and open secrets, formations of community and identity have long been understood to emerge, a matter to which I shall now turn.[82]

## PRIVACY AND SECRECY

Secrecy, as witnessed here, is often the rhetorical progression through which sanctity manifests itself in the reliquary; the seduction of audiences via the shock and awe of imperial automata; or the passing on

of military tactics and religious rites. Though these secrets manifest in the context of empire, they—and the groundbreaking ways some modern-day historians see and engage with them—also set the stage for analysis of other types of secrecy, secrecy that can fortify the bonds of communities as well as mark the desperate pleas for dignity and privacy of an individual. That will be the crux of what I discuss here, as I move away from objects of empire and focus now on the individuals who, historically, have often been misrepresented, ignored, and hidden.

The mid-to-late fifth-century *Life* of Saint Epiphanius of Salamis recounts the life of this illustrious fourth-century saint and Church Father.[83] The story tells us that Epiphanius was Jewish, only converting to Christianity when he was sixteen after a divine vision—an aspect of his life that appears to have been introduced in this retelling. His Judaism becomes an overarching motif that culminates at the moment after his death aboard a ship while sailing back home to Cyprus.

Before the ship arrives in Cyprus, a sailor approaches Epiphanius's laid-out corpse. The narrative tells us that the sailor, with whom Epiphanius had had a dispute,

> moving toward Epiphanius's feet, wished to lift up Epiphanius's cloak and see if he was circumcised. But Epiphanius, even though he lay dead, raised up his right foot and gave it to him in the face, and cast him to the stern of the ship. For two days [the sailor] lay as if dead. On the third day, the sailors lifted him and brought him to Epiphanius. When they set [the sailor] down at [Epiphanius's] feet and he touched his feet, straightaway he stood up.[84]

Here, by describing the soldier's desire to look into Epiphanius's past and reveal his religious conversion through his genitals, the author dramatizes what must have been the sailor's speculation about whether this holy figure had indeed been born Jewish. Yet, before the sailor is able to answer his impudent question by peering upon Epiphanius's private parts, the saint posthumously defends his dignity and privacy.

Let us compare the ending of Epiphanius's story with the story of Saint Marinos, composed around the same time. Marinos belongs to a group of writings about saints' lives from the fifth to ninth centuries,

where figures assigned female at birth join all-male monastic communities, changing their names and appearance and living out their lives as men.[85] While in the past, scholars have refused to see these stories as those of trans men, more recently scholars including myself and others have analyzed how these narratives present potent models for premodern trans lives, often presenting with immense care and sensitivity the stories of these figures.[86] One of the hallmarks of these narratives is the trans monks' insistence that even at their death bed, their birth-assigned sex not be revealed to anyone in the community.

In the *Vita* of Marinos, for example, a child named Mary is raised by their father after the mother dies. Once the child has come of age, the father decides that he wants to join a monastery.[87] Wishing not to be separated from their father, the child asks to have their hair shorn, be clothed as a man, and change their name to Marinos. The father obliges, and Marinos is understood as a eunuch in the community, on account of his beardless face and good looks. After Marinos's father passes away, Marinos is accused of defiling a nearby innkeeper's daughter who had copulated with a soldier. Upon conceiving a child, the innkeeper's daughter blamed "the young monk . . . the attractive one called Marinos."[88] Marinos accepts the charges, stating clearly: "I have sinned as a man."[89] Marinos is then exiled from the community. He begins living outside the monastery's gates and is handed the woman's child to raise. The narrative tells us how, seeking out milk from some shepherds, Marinos nursed the child "as its father."[90] After three years living in exile, Marinos and the child are let back into the monastery, and after that Marinos is found dead in his cell. While preparing the body for burial, the community confronts Marinos's naked body with shock and with words of praise for the monk. The monks beg God for their own forgiveness, as Marinos is absolved of his alleged sin with the innkeeper's daughter.

As in the story of Epiphanius, the investigation of the holy man's corpse is sought out to answer a question about his identity, with the desire for an answer felt more pressingly by the story's readers than by the people within the narrative. Once Marinos was prepared for burial, the innkeeper's daughter arrives at the scene, possessed by a demon in retribution for her lie. Just like the dead soldier on the ship, once she is brought to the remains of Saint Marinos, she is miraculously cured. But what is strikingly different in this narrative—and in those of other trans monks—is the absence of

Epiphanius's kick in the face. Across these stories, the trans monks often beg that their past not be revealed to the community. Many of these pleas, however, are left unheeded, though usually by accident and with a great deal of contrition.

In one story from the monastic community at Sketis, for example, we follow the life of a husband-and-wife pair who reunite later in life as monastic brothers: the husband Andronikos and his former wife, now known as Anastasios, who lives his life as a male eunuch in the community. On his deathbed, Anastasios turns to the elder and begs him, "For the sake of the Lord, do not strip me of what I am wearing, but send me to the Lord as I am, and do not let anybody other than you two alone know about me."[91] When Anastasios's soul leaves his body, the elder strips off his own cloak and hands it to his companion, instructing him to prepare the body, with the clear instruction to "Dress him in this on top of what he is wearing."[92] The story then tells us that, accidentally, "while the brother was dressing him, he looked and discovered that he was a woman, but he did not say anything."[93] In this quiet moment, we see the desire to preserve Anastasios's privacy.

After performing all the proper burial rites, the brother inquires to the elder on the way home if he had known about the monk, to which the elder replies that he had indeed known about Anastasios, going on to tell his full story. The *Vita*'s closing words then supplicate to us, the readers: "Let us pray that the Lord will make us, too, worthy of the path of the saints, and to find mercy together with our fathers, and with Abba Anastasios the Eunuch."[94] In these words, which are not uncommon in the lives of these monks, we find a moving and careful desire to respect the monk's wishes about the preparation of his body for the sake of his dignity and an affirmation of his gender identity. The story commemorates him as male and praises his uncontested sanctity as a holy man. And, throughout the narrative, the story of Anastasios is kept as a binding secret, a shared knowledge and respect forged within the bounds of the monastic community and their shared brotherhood.

In these stories, we see how secrecy is not deployed to enact and transmit the powers of the imperial state but instead to serve as a tactic for resisting the state's social and religious oppression. Secrecy allows figures to contour new spaces in which to maneuver while also fortifying the bonds between the secret keepers themselves. Unlike Procopius or QAnon, who

seek to parrot the language of revelation to oppress, and unlike the Limburg Staurotheke or the throne automata, which use the concealment of relics and objects to enchant with their revelation, the acts of secret keeping in these narratives edify the community through their bonds of silence and respect. Here, it is the act of respecting and protecting the secret that serves as the most powerful and subversive agent. Historically, such secrets, as powerful as they might be, present challenges for how we access and give voice to stories those secrets sought to protect. In a moment where the existence of queer and trans people is questioned based on the secrets we have had to keep for so long, it becomes imperative that we ask how we can conscientiously put forward the complex and nuanced dynamics of secret keeping across history and in our present.

### CONCLUSION

This respect for secrecy is a poignant reminder of the ways in which queer and trans lives in history have so often sought privacy to respect their gender identity, their freedom to live, and their dignity and memory at death. In other words, such stories point to the gaps, the aporia that the secrets we keep create in the historical record, and of how often acts of historical recuperation—undertaken merely to prove that we have existed—have been obfuscated by the secrets we have kept for our safety and the protection of our communities. As a queer scholar, I reject the suspicious ideations of generations of scholars that have sought out sexual deviance, impropriety, and crimes in these secrets—mocking queer and trans lives through toxic tropes of concealment and deceit. Instead, I am drawn to the practices of self-censorship and self-erasure that such queer subjects have often had to endure, begging poignantly for their lives to not be revealed beyond a select, chosen family. To be a scholar of (queer) history is fundamentally to have a relationality to secrets and secrecy, to the simultaneously joyful and painful speculation of what might have been that we cannot know because the subjects did not want anyone to know lest they be found out. This history is more imperiled today than ever, as transphobia and homophobia are finding renewed footings in our politics and culture, and as conspiracy theories erode our abilities to fruitfully bear witness to these stories without seeming to fall into methodologies of speculation and fabulation, in an unruly terrain that must consequently lie beyond fact-checkers and data points.

Throughout this volume, I have been able to pry into secrecy during the empire of Constantine VII Porphyrogennetos precisely because this learned emperor set off on a campaign to codify the workings of his empire in such depth that the imperial and military secrets that today would have been lost to us, like the veracity of Liutprand's description of the throne room, were codified and now appear as well-trodden ground in Byzantine studies. Across many of our tenth-century texts, we see the fleeting comments of scribes (and even Constantine VII himself) noting the immense labor and research that went into adequately compiling and collating this knowledge that had only been passed down through word of mouth or scattered across the archives of the empire. A number of the works of art that we art historians look at are similarly guilty of being the product of immense wealth and limited access that make many of their nuances and complexities secrets of the court or the religious elite.

Several of the objects and histories described here have today been the source of immense speculation, imaginary reconstructions, and revisionist histories that actively go against what the historical texts tell us. For example, both serious scholars and popular documentary filmmakers have speculated, experimented with, and reconstructed various possible formulations of Greek fire and its deployment.[95] Scientists and amateur historians have attempted to argue that the Mandylion was in fact the Shroud of Turin (which we know to be a late-medieval creation), and they have attempted to reconstruct a folding pattern and machinery of display to justify the mention of only Christ's face and the seams on the shroud.[96] Various scholars have even disputed (convincingly so) the details of the Mandylion's advent in Constantinople, arguing for differing dates of arrival, sites of deposit, and display than what *any* of the historical chronicles tell us.[97] Ultimately, the historian is caught between the seductive allures of secrecy and the challenge of historical work—work that, rather than simply parroting sources, uses modern methodologies and ideas to give voice to the past. However, when it comes to reconstructing the realities of queer and trans lives, the same generosity has often not been shared.

As mentioned at the start of this book, the portrait of King Abgar with the face of Constantine VII, holding the Mandylion with Christ's resplendent visage upon it (see fig. 3), betrays the concealment of two secrets: first, that it was the deposed Romanos I, not Constantine VII, who brought the Mandylion to Constantinople; and, second, that this object surely did not

ΤΗ ΑΥΤΗ ΗΜΕΡΑ. ΜΝΗΜΗ ΤΗС ΟСΙΑС ΜΑΡΙΑС ΤΗС
ΜΕΤΟΝΟΜΑСΘΕΙСΗС ΜΑΡΙΝΟΥ

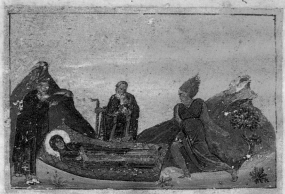

FIGURE 23
Saint Marinos on bier being approached by the innkeeper's daughter,
who has been possessed by a demon.
From the *Menologion* of Basil II, gr. 1613, p. 394.
Vatican City, Biblioteca Apostolica Vaticana.

depict Christ's face but was an aniconic linen textile. These are well-known secrets that the scholarly literature has deftly handled.

When looking at the illustration of Saint Marinos in the imperial *Menologion* of Basil II, we confront the final scene of the monk's story: the innkeeper's daughter rushing into the frame, hair standing up, possessed by a demon. Marinos has been laid to rest with the innkeeper at his side and a fellow monk at his head (fig. 23). The illustrator has chosen to dramatize the moment prior to the woman's repentance before Marinos, depicting Marinos not as male, as he lived out his life, but in female monastic attire to heighten and underscore his innocence in conceiving the child. This discrepancy is made even more striking by the fact that the title atop the page for Marinos's feast day does not list him as Mary but, rather, explicitly states: "the memory of the Holy Mary, who changed her name to Marinos."[98]

As historians, when we are confronted with texts and images like these, we must not take the easy way out. That is, we cannot say that the Byzantines saw Marinos as "a woman in disguise," as so much past scholarship has crudely dismissed such stories. Instead, we should offer such images and narratives the deft and complex nuances that we offer other works of art and literature, understanding the imperial programs behind them; the labor that images undertake and how they do that; the various (often purposeful) ways in which art, literature, and historical accounts seek to occlude certain realities and work out greater cultural anxieties; and, most importantly, how such accounts often subvert and go against our expectations of what medieval people would have done. By recognizing these nuances, we can work through veils of secrecy and privacy to see Marinos as a gender-variant figure, before modern terms existed to describe him as a trans male saint who lived out his life passing as a eunuch, just as we can see Constantine VII Porphyrogennetos as King Abgar, vying for his identity as the ruler chosen by God himself to be sole-emperor, and the Mandylion's face of Christ concealing through an image the image that was missing upon it. It is in these vicissitudes and complexities that Byzantine art has the most to show us, both about our world and the Byzantine world, and about the secrets people kept that continue to enchant us, lead us to wonder, and encourage us to speculate across loss and absence about the lives of people like us, lost to history and yet also now enlivened by it.

## NOTES

1.   For this account, see Symeon Logothetes, *Chronicle*, 136.80–81, in *Symeon Magistri et Logothetae Chronicon*, ed. Staffan Wahlgren (Berlin: Walter de Gruyter, 2006); and *The Chronicle of the Logothete*, trans. Staffan Wahlgren (Liverpool: Liverpool University Press, 2019), 249–50. For editions and translations of the various narratives of the Mandylion and its arrival into Constantinople, see Mark Guscin, *The Image of Edessa* (Leiden: Brill, 2009). See also Andrea Nicolotti, *From the Mandylion of Edessa to the Shroud of Turin: The Metamorphosis and Manipulation of a Legend* (Leiden: Brill, 2014); and Mark Guscin, *The Tradition of the Image of Edessa* (Newcastle: Cambridge Scholars Publishing, 2016). See also Ernst von Dobschütz, *Christusbilder: Untersuchungen zur christlichen Legende* (Leipzig: J. C. Hinrichs, 1899).

2.   The stories of the Mandylion are varied. For an overview, see Averil Cameron, "The History of the Image of Edessa: The Telling of a Story," in *Okeanos: Essays Presented to Ihor Ševčenko on His Sixtieth Birthday*, ed. Cyril Mango and Omeljan Pritsak (Cambridge, MA: Harvard University Press, 1984), 80–94; and Ida Toth, "The Epigraphy of the Abgar Story: Traditions and Transitions," in *Inscribing Texts in Byzantium: Continuities and Transformations*, ed. Marc D. Lauxtermann and Ida Toth (London: Routledge, 2020), 73–104. See also Gerhard Wolf, "From Mandylion to Veronica: Picturing the 'Disembodied' Face and Disseminating the True Image of Christ in the Latin West," in *The Holy Face and the Paradox of Representation: Papers from a Colloquium Held at the Bibliotheca Hertziana, Rome and the Villa Spelman, Florence, 1996*, ed. Herbert Kessler and Gerhard Wolf (Bologna: Nuova Alfa, 1998), 153–79; and Isa Ragusa, "Mandylion-Sudarium: The 'Translation' of a Byzantine Relic to Rome," *Arte Medievale*, ser. 2, 5, no. 2 (1991): 97–106.

3.   Averil Cameron, "The Mandylion and Byzantine Iconoclasm," in Kessler and Wolf, *The Holy Face*, 33–54; and Charles Barber, *Figure and Likeness: On the Limits of Representation in Byzantine Iconoclasm* (Princeton, NJ: Princeton University Press, 2002), 13–37. On the function of the Mandylion more broadly, see Herbert Kessler, *Spiritual Seeing: Picturing God's Invisibility in Medieval Art* (Philadelphia: University of Pennsylvania Press, 2000), esp. 64–87; Hans Belting, *Likeness and Presence: A History of the Image before the Era of Art*, trans. Edmund Jephcott (Chicago: University of Chicago Press, 1994), esp. 49–57, 208–4; and Horst Bredekamp, *Image Acts: A Systemic Approach to Visual Agency*, trans. Elizabeth Clegg (Berlin: De Gruyter, 2018), 137–92.

4.   On the arrival and display of the Mandylion, see Sysse G. Engberg, "Romanos Lekapenos and the Mandylion of Edessa," in *Byzance et les reliques du Christ*, ed. Jannic Durand and Bernard Flusin (Paris: Association des amis du Centre d'histoire et civilisation de Byzance, 2004), 123–42; and Bernard Flusin, "L'image d'Édesse, Romain et Constantin," in *Sacre impronte e oggetti "non fatti da mano d'uomo" nelle religioni: Atti del Convegno Internazionale-Torino, 18–20 maggio 2010*, ed. A. Monaci Castagno (Alessandria: Edizioni dell'Orso, 2011), 253–77. See also Michele Bacci, "Relics of the Pharos Chapel: A View from the Latin West," in *Eastern Christian Relics*, ed. Alexi Lidov (Moscow: Progress-Tradition, 2003), 234–46, esp. 243–45.

5.   Pseudo-Symeon Magister, *Chronographia*, 52, in *Symeon Magistri*, ed. Immanuel Bekker (Bonn: Weber, 1838), 750–51.

6.   On the concealment of the Mandylion, see Annemarie Weyl Carr, "Court Culture and Cult of Icons in Middle Byzantine Constantinople," in *Byzantine Court Culture from 829 to 1204*, ed. Henry Maguire (Washington, DC: Dumbarton Oaks, 1997), 81–91, esp. 88–89.

7.   For a tenth-century liturgical treatise recounting this procession and rite, see *Die liturgische Traktat*, in Dobschütz, *Christusbilder*, 107\*\*–114\*\*, esp. 111\*\*–112\*\*. Translated in Bissera Pentcheva, "The Performance of Relics: Concealment and Desire in the Byzantine Staging of *Leipsana*," in ΣΥΜΜΕΙΚΤΑ: *Collection of Papers Dedicated to the 40th Anniversary of the Institute for Art History, Faculty of Philosophy, University of Belgrade*, ed. Ivan Stevović (Belgrade: University of Belgrade, 2012), 55–71, at 62–64.

8.  Pentcheva, "The Performance of Relics," 57.

9.  Many scholars have noted that the Mandylion most likely did not depict anything clearly figural. For example, see Karin Krause, *Divine Inspiration in Byzantium: Notions of Authenticity in Art and Theology* (Cambridge: Cambridge University Press, 2022), 293–300. See also Kessler, *Spiritual Seeing,* esp. 64–87.

10.  On Constantine VII and the Mandylion, see Roland Betancourt, "Between Wonder and Omen: Conjoined Twins and the Mandylion from Constantinople to Norman Sicily," *Gesta* 62, no. 1 (2023): 23–62. See also Kurt Weitzmann, "The Mandylion and Constantine Porphyrogennetos," in *Studies in Classical and Byzantine Manuscript Illumination,* ed. Herbert Kessler (Chicago: University of Chicago Press, 1971), 224–46.

11.  On the panel, see Kathleen Corrigan, "Two Icon Panels with Saints Thaddaeus, Paul of Thebes, and Antony (left), and King Abgar and Messenger (Ananias?), and Saints Basil and Ephrem (right)," in *Byzantium and Islam: Age of Transition,* ed. Helen C. Evans and Brandie Ratliff, exh. cat. (New York: Metropolitan Museum of Art, 2012), 58. See also Robert S. Nelson and Kristen M. Collins, *Holy Image, Hallowed Ground: Icons from Sinai,* exh. cat. (Los Angeles: J. Paul Getty Museum, 2006), cat. no. 6.

12.  Seeta Chaganti, *The Medieval Poetics of the Reliquary: Enshrinement, Inscription, Performance* (New York: Palgrave Macmillan, 2008), 77.

13.  Jaś Elsner, "Relic, Icon, and Architecture: The Material Articulation of the Holy in East Christian Art," in *Saints and Sacred Matter: The Cult of Relics in Byzantium and Beyond,* ed. Cynthia Hahn and Holger A. Klein (Washington, DC: Dumbarton Oaks, 2015), 13–40, at 18. For the best study of Middle Byzantine inscriptions on reliquaries, see Brad Hostetler, "The Function of Text: Byzantine Reliquaries with Epigrams, 843–1204" (PhD diss., Florida State University, 2016).

14.  On the Limburg Staurotheke, see Brad Hostetler, "The Limburg Staurotheke: A Reassessment," *Athanor* 30 (2012): 7–13; Nancy Ševčenko, "The Limburg Staurothek and Its Relics," in *Thymiama stē mnēmē tēs Laskarinas Boura* (Athens: Benaki Museum, 1994), 289–94; Bissera V. Pentcheva, "Containers of Power: Eunuchs and Reliquaries in Byzantium," *Res: Anthropology and Aesthetics* 51 (2007): 107–20; and Holger A. Klein, "Die Limburger Staurothek und der Kreuzkult in Jerusalem und Konstantinopel," *Im Zeichen des Kreuzes: Die Limburger Staurothek und ihre Geschichte,* ed. August Heuser and Matthias T. Kloft (Regensburg: Schnell & Steiner, 2009), 13–30. See also Jakob Rauch, "Die Limburger Staurothek," *Das Münster* 8 (1955): 205–12; and Johann Michael Wilm, "Die Heilige Kreuzreliquie," *Das Münster* 8 (1955): 234–40.

15.  On the relics of the True Cross and their reliquaries, see Anatole Frolow, *La relique de la Vraie Croix; recherches sur le développement d'un culte* (Paris: Institut français d'études byzantines, 1961); and Anatole Frolow, *Les reliquaires de la Vraie Croix* (Paris: Institut français d'études byzantines, 1965).

16.  "Οὐ κάλλος εἶχεν ὁ κρεμασθεὶς ἐν ξύλῳ, / ἀλλ᾽ ἦν ὡραῖος κάλλει Χριστὸς καὶ θνήσκων· / οὐκ εἶδος εἶχεν, ἀλλ᾽ ἐκαλλώπιζέ μου / τὴν δυσθέατον ἐξ ἁμαρτίας θέαν· / Θεὸς γὰρ ὢν ἔπασχεν ἐν βροτῶν φύσει· ὃν Βασίλειος [ὁ] πρόεδρος ἐξόχως / σέβων ἐκαλλώπ[ι]σε τὴν θήκην ξύλου / ἐν ᾧ τανυσθεὶς εἵλκυσεν πᾶσαν κτίσιν." Transcribed in Andreas Rhoby, *Byzantinische Epigramme auf Ikonen und Objekten der Kleinkunst,* vol. 2 (Vienna: Verlag der Österreichischen Akademie der Wissenschaften, 2010), 163–69, at 166. Translation modified from Hostetler, "The Limburg Staurotheke," 7n5. On the order of the verses, see Erica Follieri, "L'ordine dei versi in alcuni epigrammi bizantini," *Byzantion* 34 (1964): 447–46; Johannes Koder, "Zu den Versinschriften der Limburger Staurothek," *Archiv für mittelrheinische Kirchengeschichte* 37 (1985): 11–31; and Wolfram Hörandner, "Das byzantinische Epigramm und das heilige Kreuz: Einige Beobachtungen zu Motiven und Typen," in *La Croce: Iconografia e interpretazione, secoli I—inizio XVI,* ed. Boris Ulianich and Ulderico Parente, 3 vols. (Naples: E. de Rosa, 2007), 3:107–25. For an earlier transcription, see E. Cougny, *Epigrammatum anthologia Palatina cum Planudeis et appendice nova,* vol. 3 (Paris: Didot, 1890), 356 (nos. 408 and 409).

17. On the relics, see Ševčenko, "The Limburg Staurothek and Its Relics," 289–94.

18. Ševčenko, "The Limburg Staurothek and Its Relics," 291.

19. Ševčenko, "The Limburg Staurothek and Its Relics," 292.

20. "Θ[εὸ]ς μὲν ἐξέτεινε χεῖρας ἐν ξύλῳ / ζωῆς δι' αὐτοῦ τὰς ἐνεργείας βρύων· / Κωνσταντῖνος δὲ κ[αὶ] Ῥωμανὸς δεσπόται / λίθων διαυγῶν συνθέσει κ[αὶ] μαργάρων / ἔδειξαν αὐτὸ θαύματος πεπλησμένον· / καὶ πρὶν μὲν Ἅίδου Χ[ριστὸ]ς ἐν τούτῳ πύλας / θραύσας ἀνεζώωσε τοὺς τεθνηκότας· / κοσμήτορες τούτου δὲ νῦν στεφηφόροι / θράση δι' αὐτοῦ συντρίβουσι βαρβάρων." Transcribed in Rhoby, Byzantinische Epigramme, 166. Translation derived from Hostetler, "The Limburg Staurotheke," 8.

21. On art and warfare, see Robert S. Nelson, "'And so, with the Help of God': The Byzantine Art of War in the Tenth Century," Dumbarton Oaks Papers 65/66 (2011–12): 169–92.

22. This, for example, was the same title that Theophanes bore when he received the Mandylion at the Sagaros River and brought it to Constantinople, and both these eunuchs had also been successful generals with many defeats against the enemies of the empire. On Basil Lekapenos and his titles, see Walter Gerhard Brokkar, "Basil Lekapenos," in Studia Byzantina et Neohellenica Neerlandica, ed. Willem Frederik Bakker, A. F. van Gemert, and Willem H. Aerts (Leiden: Brill, 1972), 199–235; and Carlo Maria Mazzucchi, "Dagli anni di Basilio Parakimomenos (Cod. Ambr. B 119 Sup.)," Aevum 52 (1978): 267–316. On Basil patronage, see Pentcheva, "Containers of Power," 107–20; Laskarina Bouras, "Ὁ Βασίλειος Λεκαπηνός παραγγελιοδότης ἔργων τέχνης," in Κωνσταντῖνος Ζ' ὁ Πορφυρογέννητος καὶ ἡ ἐποχή του. Β' Διεθνής Βυζαντινολογική Συνάντηση, ed. Athanasios Markopoulos (Athens: Eurōpaiko Politistiko Kentro Delphōn, 1989), 397–434; and Marvin Ross, "Basil the Proedros: Patron of the Arts," Archaeology 11 (1958): 271–75. See also Shaun Tougher, "Generalship and Gender in Byzantium: Non-Campaigning Emperors and Eunuch Generals in the Age of the Macedonian Dynasty," in Generalship in Ancient Greece, Rome and Byzantium, ed. Richard Evans and Shaun Tougher (Edinburgh: Edinburgh University Press, 2022), 264–83.

23. On the Cortona Reliquary, see Holger Klein, "Die Elfenbein-Staurothek von Cortona im Kontext mittelbyzantinischer Kreuzreliquiarproduktion," in Spätantike und byzantinische Elfenbeinbildwerke im Diskurs, ed. Gudrun Bühl, Anthony Cutler, and Arne Effenberger (Wiesbaden: Reichert, 2008), 167–90. See also Frolow, La relique, 239–41.

24. "Κ[αὶ] πρὶν κραταιῷ δεσπότῃ Κωνσταντίνῳ / Χ[ριστὸ]ς δέδωκε στ[αυρ]ὸν εἰ[ς] σωτηρίαν· / κ[αὶ] νῦν δὲ τοῦτον ἐν Θ[ε]ῷ Νικηφόρος / ἄναξ τροποῦται φῦλα βαρβάρων ἔχων." Transcribed in Rhoby, Byzantinische Epigramme, 331–34, at 332.

25. On the demonstrative, see Hostetler, "The Limburg Staurotheke," 11.

26. On the typology of these past and present deeds, see Hostetler, "The Limburg Staurotheke," 8–9; and Nelson, "'And so, with the Help of God,'" 182–85.

27. Ševčenko, "The Limburg Staurothek and Its Relics," 291.

28. On the intersections of religious and military power in Byzantine warfare, see Paul Stephenson, "Imperial Christianity and Sacred War in Byzantium," in Belief and Bloodshed: Religion and Violence across Time and Tradition, ed. James K. Wellman Jr. (Lanham, MD: Rowman & Littlefield, 2007), 81–96. See also Cynthia Hahn, Strange Beauty: Issues in the Making and Meaning of Reliquaries, 400–circa 1204 (University Park: Pennsylvania State University Press, 2012), 153–57.

29. For a useful overview, see Michael McCormick, Eternal Victory: Triumphal Rulership in Late Antiquity, Byzantium, and the Early Medieval West (Cambridge: Cambridge University Press, 1986), esp. 232–52.

30. "κουβικουλάριος βαστάζων τὰ τίμια καὶ ζωοποιὰ ξύλα μετὰ τῆς θήκης ἐπὶ τοῦ τραχήλου." Constantine VII Porphyrogennetos, Military Treatises, C.486, in Three Treatises on Imperial Military Expeditions, ed. and trans. John Haldon (Vienna: Verlag der Österreichischen Akademie der Wissenschaften, 1990), 124–25.

Betancourt

31.   John of Damascus, *Three Treatises on the Divine Images*, 3:34, in *Die Schriften des Johannes von Damaskos*, ed. P. Bonifatius Kotter, 7 vols. (Berlin: De Gruyter, 1969–2013), 3:139. Translated in Andrew Louth, *Three Treatises on the Divine Images* (Crestwood, NY: St. Vladimir's Seminary Press, 2003), 108.

32.   "ἀπομυρίσαντες ἐξαπεστείλαμεν ὑμῖν ἁγίασμα τοῦ ῥαντισθῆναι ἐφ' ὑμῖν καὶ δι' αὐτοῦ περιχρισθῆναι καὶ θείαν ἐξ ὕψους ἐπενδύσασθαι δύναμιν." Constantine VII Porphyrogennetos, *Military Oration*, 8.23–31, in "Zum historischen Exzerptenwerke des Konstantinos Porphyrogennetos," ed. R. Vári, *Byzantinische Zeitschrift* 17 (1908): 78–84, at 83. Translated in Eric McGeer, "Two Military Orations of Constantine VII," in *Byzantine Authors: Literary Activities and Preoccupations*, ed. John W. Nesbitt (Leiden: Brill, 2003), 111–35, at 133.

33.   On Roman medical objects, see Ralph Jackson, *Doctors and Diseases in the Roman Empire* (London: British Museum Press, 1988). See also Lawrence J. Bliquez, "Two Lists of Greek Surgical Instruments and the State of Surgery in Byzantine Times," *Dumbarton Oaks Papers* 38 (1984): 187–204. More broadly, see Alain Touwaide, "Medicine and Pharmacy," in *A Companion to Byzantine Science*, ed. Stavros Lazaris (Leiden: Brill, 2020), 354–403.

34.   Hahn, *Strange Beauty*, 70–71.

35.   "πανδέκται μετὰ παντοίων ἐλαίων καὶ βοηθημάτων καὶ παντοίων ἐμπλάστρων καὶ ἀλοιφῶν καὶ ἀλημμάτων καὶ λοιπῶν ἰατρικῶν εἰδῶν, βοτανῶν καὶ λοιπῶν τῶν εἰς θεραπείαν ἀνθρώπων καὶ κτηνῶν τυγχανόντων." Constantine VII Porphyrogennetos, *Military Treatises*, C.205, in Haldon, *Three Treatises*, 106–207.

36.   For a survey of military saints, see Monica White, *Military Saints in Byzantium and Rus, 900–1200* (Cambridge: Cambridge University Press, 2013), esp. 64–93; and Christopher Walter, *The Warrior Saints in Byzantine Art and Tradition* (Surrey: Ashgate, 2003). Unfortunately, the front medallion of Saint Demetrios is now missing. The back medallion of Saint George still remains. See Rhoby, *Byzantinische Epigramme*, 216–18, esp. 217.

37.   "αἵματι τῷ σῷ καὶ μύρῳ κεχρισμένον. Αἰτεῖ σε θερμὸν φρουρὸν ἐν μάχαις ἔχειν." Rhoby, *Byzantinische Epigramme*, 217. See also Brad Hostetler, "Towards a Typology for the Placement of Names on Works of Art," in Lauxtermann and Toth, *Inscribing Texts in Byzantium*, 267–90, esp. 279. For earlier treatments of the inscription, see Dimitrios G. Katsarelias, "Enkolpion Reliquary of Saint Demetrios," in *The Glory of Byzantium: Art and Culture of the Middle Byzantine Era*, ed. Helen C. Evans and William D. Wixom, exh. cat. (New York: Metropolitan Museum of Art, 1997), 167–68.

38.   On the history of the myron and the cult of Saint Demetrios, see Charalambos Bakirtzis, "Pilgrimage to Thessalonike: The Tomb of St. Demetrios," *Dumbarton Oaks Papers* 56 (2002): 175–92. See also Franz Alto Bauer, *Eine Stadt und ihr Patron: Thessaloniki und der Heilige Demetrios* (Regensburg: Schnell & Steiner, 2013); and Robin Cormack, "The Making of a Patron Saint: The Powers of Art and Ritual in Byzantine Thessaloniki," in *World Art: Themes of Unity in Diversity; Acts of the XXVIth International Congress of the History of Art*, ed. Irving Lavin, vol. 3 (University Park: Pennsylvania State University Press, 1989), 547–54.

39.   John Staurakios, *Miracles of St. Demetrios*, in "Ἰωάννου Σταυρακίου λόγος εἰς τὰ θαύματα τοῦ ἁγίου Δημητρίου," ed. Ioakeim Iberites, *Makedonika* 1 (1940): 324–76, esp. 353, 373–74.

40.   See Walter, *Warrior Saints*, 67.

41.   See Gary Vikan, *Early Byzantine Pilgrimage Art*, rev. ed. (Washington, DC: Dumbarton Oaks, 2010), esp. 20–23. On the ampullae of Demetrios, see Charalambos Bakirtzis, "Byzantine Ampullae from Thessaloniki," in *The Blessings of Pilgrimage*, ed. Robert Ousterhout (Urbana: University of Illinois Press, 1990), 140–49.

42.   Walter, *Warrior Saints*, 81 (italics in original).

43.   On the complex ways in which one reliquary from the site plays with the absence and presence of the saint, see Laura Veneskey, "Truth and Mimesis in Byzantium: A Speaking Reliquary of Saint Demetrios of Thessaloniki," *Art History* 42, no. 1 (2019): 16–39.

The Secrets We Keep

44. "ἀλλὰ οὐδὲ τῶν σκευαστῶν ἴσον ἐτέρων." Demetrios Chrysoloras, *Oration on the St. Demetrios and the Holy Oil*, in "Λόγος εἰς τὸν μέγαν Δημήτριον καὶ εἰς τὰ μύρα," ed. Basileios Laourdas, *Gregorios Palamas* 40 (1957): 342–53, at 349.

45. "σκευαστὸν τὸ μύρον τουτὶ ἐπιδαψιλεύεται." Staurakios, *Miracles of St. Demetrios*, in Iberites, "Ἰωάννου Σταυρακίου," 351.

46. Patrick Geary, *Furta Sacra: Thefts of Relics in the Central Middle Ages, 800–1100*, rev. ed. (Princeton, NJ: Princeton University Press, 1990).

47. Christopher of Mytilene, *Poems*, 114, in *The Poems of Christopher of Mytilene and John Mauropous*, ed. and trans. Floris Bernard and Christopher Livanos (Cambridge, MA: Harvard University Press, 2018), 241–51. For a fuller discussion of this poem, see Roland Betancourt, "Icon, Eucharist, Relic: Negotiating the Division of Sacred Matter in Byzantium," in *Byzantine Materiality*, ed. Evan Freeman and Roland Betancourt (Berlin: Walter de Gruyter, 2024), 193–234.

48. "Βαβαὶ ζεούσης πίστεως σῆς, Ἀνδρέα, / ἥτις σε πείθει τοὺς μὲν ἀθλητὰς Ὕδρας, / τὰς μάρτυρας δὲ θῆρας οἴεσθαι κύνας, / τοὺς μὲν κεφαλὰς μυρίας κεκτημένους, / τὰς δ' αὖ γε μαθῶν πλῆθος ὥσπερ αἱ κύνες." Christopher of Mytilene, *Poems*, 114:21–25, in Bernard and Livanos, *Poems*, 242–43.

49. "ἅπαν τε κύκλῳ βάμματι χρίσας κρόκου / καὶ θυμιάσας καὶ περιστείλας ἅμα." Christopher of Mytilene, *Poems*, 114:79–84, at 79–80, in Bernard and Livanos, *Poems*, 246–47.

50. On the automata of the throne room, see James Trilling, "Daedalus and the Nightingale: Art and Technology in the Myth of the Byzantine Court," in Maguire, *Byzantine Court Culture*, 217–30. See also Gerard Brett, "The Automata in the Byzantine 'Throne of Solomon,'" *Speculum* 29, no. 3 (1954): 477–87. On medieval automata more broadly, see E. R. Truitt, *Medieval Robots: Mechanism, Magic, Nature, and Art* (Philadelphia: University of Pennsylvania Press, 2015), esp. 12–39.

51. Liutprand of Cremona, *Retribution*, 6.5, in *The Complete Works of Liudprand of Cremona*, trans. Paolo Squatriti (Washington, DC: Catholic University of America Press, 2007), 197–98.

52. This audience hall is similarly described in the *Book of Ceremonies*, an internal manual for court ceremony codified by Constantine VII as well. Constantine VII Porphyrogennetos, *The Book of Ceremonies*, trans. Ann Moffatt and Maxeme Tall (Leiden: Brill, 2012), 566–70, esp. 569.

53. Alfred Gell, "The Technology of Enchantment and the Enchantment of Technology," in *Anthropology, Art, and Aesthetics*, ed. Jeremy Coote and Anthony Shelton (Oxford: Clarendon, 1992), 40–63.

54. Gell, "The Technology of Enchantment," 47–48.

55. *Le voyage de Charlemagne*, in *Le pélerinage de Charlemagne*, ed. and trans. Glyn S. Burgess (New York: Garland, 1988).

56. "E fu fait par cumpas et serét noblement." *Le voyage de Charlemagne*, l. 348, in Burgess, *Le pélerinage*, 46.

57. On this passage, see Truitt, *Medieval Robots*, 12–14.

58. Heron of Byzantium, *Parangelmata Poliorcetica*, 1.1–8, in *Siegecraft: Two Tenth-Century Instructional Manuals by "Heron of Byzantium,"* ed. and trans. Denis F. Sullivan (Washington, DC: Dumbarton Oaks Research Library and Collection, 2000), 26–27. Translation modified by author. On this text, see Roland Betancourt, "Bellicose Things: The Inner Lives of Byzantine Warfare Implements," *Word & Image* 37, no. 2 (2021): 160–77.

59. "δι' ἀβλεψίας καὶ ἀγνωσίας ἰδεῖν καὶ γνῶναι τὸν ὑπὲρ θέαν καὶ γνῶσιν." Pseudo-Dionysios, *De mystica theologica*, 2.1, in *Corpus Dionysiacum*, ed. Günter Heil and Adolf M. Ritter, vol. 2 (Berlin: De Gruyter, 1991), 145. See Sullivan, *Siegecraft*, 9.

60. Michael Psellos, *Letters*, 188, in Μεσαιωνικὴ Βιβλιοθήκη, ed. K. Sathas, vol. 4 (Paris: n.p., 1876), 477–80. Translated in Paul Magdalino and Maria Mavroudi, "Introduction," in *The Occult Sciences in Byzantium*, ed. Paul Magdalino and Maria Mavroudi (Geneva: La Pomme d'or, 2006), 11–37, at 19.

Betancourt

61.  On this language of secrecy, see Magdalino and Mavroudi, "Introduction," 15–20.

62.  Cf. H. R. Ellis Davidson, "The Secret Weapon of Byzantium," *Byzantinische Zeitschrift* 66 (1973): 61–74. See Liutprand of Cremona, *Retribution*, III.25; 5.9, 14, 16, in Squatriti, *Complete Works*, 120, 176, 179, 181.

63.  For an overview of the terminology and succinct introduction to the weapon, see John Haldon with Andrew Lacey and Colin Hewes, "'Greek Fire' Revisited: Recent and Current Research," in *Byzantine Style, Religion and Civilization: In Honor of Sir Steven Runciman*, ed. Elizabeth Jeffreys (Cambridge: Cambridge University Press, 2006), 290–325.

64.  For the most comprehensive study, see Haldon, "'Greek Fire.'" For the earlier bibliography, see John Haldon and Maurice Bryne, "A Possible Solution to the Problem of Greek Fire," *Byzantinische Zeitschrift* 70 (1977): 91–99.

65.  "στρεπτῶν ἐγχειριδίων πυροβόλων κατὰ πρόσωπον τῶν πολεμίων διὰ πυρὸς ἀκοντίζουσι, τοσοῦτον τοὺς τείχει προεστῶτας πτοήσουσιν, ὥστε τὴν ἀπὸ τῆς μάχης προσβολὴν καὶ τὴν τοῦ πυρὸς μὴ ὑποφέροντας ῥύμην τάχιον αὐτοὺς ὑπεκφεύξεσθαι τοῦ τόπου." Heron of Byzantium, *Parangelmata Poliorcetica*, 49.19–25, in Sullivan, *Siegecraft*, 98–99.

66.  "οὔτε παρὰ ἀνθρώπων κατεσκευάσθησαν, οὔτε ἐξ ἀνθρωπίνων τεχνῶν ἐπενοήθησαν ἢ ἐξηργάσθησαν." Constantine VII Porphyrogennetos, *De administrando imperio*, 13, in *De administrando imperio*, ed. Gy. Moravcsik and trans. R. J. H. Jenkins, rev. ed. (Washington, DC: Dumbarton Oaks, 1967), 66–67.

67.  "ὡς ἀπὸ παλαιᾶς ἱστορίας ἐν ἀπορρήτοις λόγοις γεγραμμένον εὑρίσκομεν" Constantine VII Porphyrogennetos, *De administrando imperio*, 13, in Moravcsik and Jenkins, *De administrando imperio*, 66–67.

68.  Constantine VII Porphyrogennetos, *De administrando imperio*, 13, in Moravcsik and Jenkins, *De administrando imperio*, 68–69.

69.  Constantine VII Porphyrogennetos, *De administrando imperio*, 13, in Moravcsik and Jenkins, *De administrando imperio*, 70–71.

70.  Constantine VII Porphyrogennetos, *De administrando imperio*, 53, in Moravcsik and Jenkins, *De administrando imperio*, 284–85.

71.  On this section of the text, see Haldon, "'Greek Fire,'" esp. 291–93.

72.  Dioscurides, *De materia medica*, 1.73.2, in *Pedanii Dioscuridis Anazarbei de materia medica libri quinque*, ed. Max Wellmann, vol. 1 (Berlin: Weidmann, 1907).

73.  Constantine VII Porphyrogennetos, *De administrando imperio*, 48, in Moravcsik and Jenkins, *De administrando imperio*, 226–27.

74.  George Kedrenos, *Historical Compendium*, in *Georgius Cedrenus, Joannis Scylitzae ope*, ed. Immanuel Bekker, vol. 1 (Bonnae: Impensis Ed. Weberi, 1838), 765.

75.  "ἐκ τούτου κατάγεται ἡ γενεὰ τοῦ Λαμπροῦ τοῦ νυνὶ τὸ πῦρ ἐντέχνως κατασκευάζοντος." Kedrenos, *Historical Compendium*, in Bekker, *Georgius Cedrenus*, 765.

76.  Alex Roland, "Secrecy, Technology, and War: Greek Fire and the Defense of Byzantium, 678–1204," *Technology and Culture* 33, no. 4 (1992): 655–79.

77.  Pamela O. Long, *Openness, Secrecy, Authorship: Technical Arts and the Culture of Knowledge from Antiquity to the Renaissance* (Baltimore: Johns Hopkins University Press, 2001).

78.  Shannon Steiner, "Byzantine Enamel and the Aesthetics of Technology Power, Ninth to Twelfth Centuries" (PhD diss., Bryn Mawr College, 2020). See dissertation abstract for a summary of this work.

79.  See, for instance, a classic study on secrecy and social formations: Georg Simmel, "The Sociology of Secrecy and of Secret Societies," *American Journal of Sociology* 11, no. 4 (1906): 441–584.

80.  Benjamin Saltzman, *Bonds of Secrecy: Law, Spirituality, and the Literature of Concealment in Early Medieval England* (Philadelphia: University of Pennsylvania Press, 2019).

The Secrets We Keep

81.  Saltzman, *Bonds of Secrecy*, 246.

82.  The open secret, in particular, plays a critical role in Eve Kosofsky Sedgwick's formulations in *Epistemology of the Closet*, a foundational text in queer theory, whose interests emerged from D. A. Miller's own theorization in an earlier article. See Eve Kosofsky Sedgwick, *Epistemology of the Closet* (Berkeley: University of California Press, 1990). See also D. A. Miller, "Secret Subjects, Open Secrets," *Dickens Studies Annual* 14 (1985): 17–38.

83.  On Epiphanius of Salamis, see Young Richard Kim, *Epiphanius of Cyprus: Imagining an Orthodox World* (Ann Arbor: University of Michigan Press, 2015); and Andrew S. Jacobs, *Epiphanius of Cyprus: A Cultural Biography of Late Antiquity* (Oakland: University of California Press, 2016). On his *Life*, see also Claudia Rapp, "Epiphanius of Salamis: The Church Father as Saint," in *The Sweet Land of Cyprus: Papers Given at the Twenty-Fifth Jubilee Spring Symposium of Byzantine Studies, Birmingham, March 1991*, ed. A. A. M. Bryer and G. S. Georghallides (Nicosia: University of Birmingham Centre for Byzantine, Ottoman and Modern Greek Studies, 1995), 169–87.

84.  *Vita Epiphanii*, 124, translation in Claudia Rapp, "The *Vita* of Epiphanius of Salamis: An Historical and Literary Study," 2 vols. (PhD diss., Oxford University, 1991), 2:206–7.

85.  There is an extensive bibliography on these saints. See Patricia Cox Miller, "Is There a Harlot in This Text? Hagiography and the Grotesque," *Journal of Medieval and Early Modern Studies* 33, no. 3 (2003): 419–35; Stephen J. Davis, "Crossed Texts, Crossed Sex: Intertextuality and Gender in Early Christian Legends of Holy Women Disguised as Men," *Journal of Early Christian Studies* 10, no. 1 (2002): 1–36; Evelyne Patlagean, "L'histoire de la femme déguisée en moine et l'évolution de la sainteté féminine à Byzance," *Studi Medievali*, ser. 3, 17 (1976): 597–623; John Anson, "The Female Transvestite in Early Monasticism: The Origin and Development of a Motif," *Viator* 5 (1974): 1–32; Kari Vogt, "'The Woman Monk': A Theme in Byzantine Hagiography," in *Greece and Gender*, ed. Brit Berggreen and Nanno Marinatos (Bergen: Norwegian Institute at Athens, 1995), 141–48; Crystal Lynn Lubinsky, *Removing Masculine Layers to Reveal a Holy Womanhood: The Female Transvestite Monks of Late Antique Eastern Christianity* (Turnhout: Brepols, 2013); Valerie R. Hotchkiss, *Clothes Make the Man: Female Cross Dressing in Medieval Europe* (New York: Garland, 1996); Stavroula Constantinou, "Holy Actors and Actresses: Fools and Cross-Dressers as the Protagonists of Saints' Lives," in *The Ashgate Research Companion to Byzantine Hagiography*, ed. Stephanos Efthymiadis, vol. 2 (Burlington, VT: Ashgate, 2014), 343–62; and Vern L. Bullough, "Transvestites in the Middle Ages," *American Journal of Sociology* 79, no. 6 (1974): 1381–94; cf. Vern L. Bullough, "Transvestivism in the Middle Ages," in *Sexual Practices and the Medieval Church*, ed. Vern L. Bullough and James Brundage (Buffalo, NY: Prometheus, 1982), 43–54.

86.  On recent interventions, see Betancourt, *Byzantine Intersectionality*, 89–120; Gabrielle M. W. Bychowski, "The Authentic Lives of Transgender Saints," in *Trans and Genderqueer Subjects in Medieval Hagiography*, ed. Alicia Spencer-Hall and Blake Gutt (Amsterdam: Amsterdam University Press, 2021), 245–65; Robert Mills, *Seeing Sodomy in the Middle Ages* (Chicago: University of Chicago Press, 2015), esp. 81–132; and Robert Mills, "Visibly Trans? Picturing Saint Eugenia in Medieval Art," *TSQ* 5, no. 4 (2018): 540–64. See also Roland Betancourt, "Where Are All the Trans Women in Byzantium?," in *Trans Historical: Gender Plurality Before the Modern*, ed. Masha Raskolnikov, Greta LaFleur, and Anna Kłosowska (Ithaca, NY: Cornell University Press, 2021), 297–321.

87.  *Life of Marinos*, trans. Nicholas Constas as "Life of St. Mary/Marinos," in *Holy Women of Byzantium: Ten Saints' Lives in English Translation*, ed. Alice-Mary Talbot (Washington, DC: Dumbarton Oaks, 1996), 1–12.

88.  *Life of Marinos*, 9, in Constas, "Life," 9.

89.  *Life of Marinos*, 12, in Constas, "Life," 10.

90.  *Life of Marinos*, 14, in Constas, "Life," 10.

91.  "διὰ τὸν Κύριον μὴ ἀποδύσητέ με ἃ φορῶ, ἀλλ᾽ ὥς εἰμι οὕτως πέμψατέ με πρὸς Κύριον, καὶ μὴ μάθῃ ἄλλος τις τὰ περὶ ἐμοῦ εἰ μὴ ὑμεῖς μόνοι." *Life of Anastasios*, 39–41, in *Saint Daniel of Sketis:*

A Group of Hagiographic Texts Edited with Introduction, Translation and Commentary, ed. and trans. Britt Dahlman (Uppsala: Acta Universitatis Upsaliensis, 2007), 182–83.

92. "ἔνδυσον αὐτὸν ἐπάνω ὧν φορεῖ." Life of Anastasios, 50, in Dahlman, Saint Daniel, 182–83.

93. "ἐνδύων δὲ αὐτὸν ὁ ἀδελφὸς προσέσχε καὶ ἐπέγνω ὅτι γυνὴ ἦν, ἀλλ᾿ οὐδὲν ἐλάλησε." Life of Anastasios, 51–52, in Dahlman, Saint Daniel, 182–83.

94. "εὐξώμεθα οὖν ὅπως καὶ ἡμᾶς ὁ Κύριος ἀξίους ποιήσῃ τοῦ δρόμου τῶν ἁγίων καὶ εὑρεῖν ἔλεος μετὰ τῶν πατέρων ἡμῶν καὶ μετὰ τοῦ ἀββᾶ Ἀναστασίου τοῦ Εὐνούχου." Life of Anastasios, 84–86, in Dahlman, Saint Daniel, 184–86.

95. Haldon, "'Greek Fire,'" esp. 297–315.

96. John Jackson, "The Shroud of Turin as the Byzantine Shroud of Constantinople: The Scientific Evidence for the Man of Sorrows Icon Tradition," in Relikvii v iskusstve i kul'ture vostočnochristianskogo mira = Relics in the Art and Culture of the Eastern Christian World, ed. Alexei Lidov (Moscow: Radunitsa, 2000), 37.

97. On the counternarratives regarding the Mandylon's arrival, see Engberg, "Romanos Lekapenos and the Mandylion," 123–42; and Flusin, "L'image d'Édesse," 253–77.

98. "μνήμη τῆς ὁσίας Μαρίας τῆς μετονομασθείσης Μαρίνου" (Vat. gr. 1613, p. 394). Notably, the same titular can be found in the tenth-century Synaxarion of Constantinople. See Synaxarion of Constantinople, Feb. 12, in Synaxarium ecclesiae Constantinopolitanae, ed. H. Delehaye (Brussels: Apud Socios Bollandistes, 1902), 460.

# THE CHALLENGE OF HISTORY

In an article published on 12 July 2021, Vladimir Putin makes the spurious claim that the Russians and Ukrainians are one people, separated by the discord sown by late-medieval Latinization and modern Western propaganda, which fueled anti-Russian sentiments.[1] This text has been routinely cited as the Russian Federation's legitimization of the invasion of Ukraine through medieval antecedents and imperial continuation, traceable back to Byzantium. In Putin's words, "The spiritual choice made by St. Vladimir, who was both Prince of Novgorod and Grand Prince of Kiev, still largely determines our affinity today."[2] Here, the contouring of this history, for Putin, is built on a simplistic collation of dates and events that seek to present a monolithic view of the complexities and diversities of medieval peoples. Most interestingly, Putin provides in his essay a methodological disclaimer that he worked with "well-known

facts rather than on some secret records," implicitly speaking to a status quo history, attempting a clear and distinct inversion of the speculative and conspiracy-driven approaches that have become the standard practice in our online spheres today.[3] In postulating himself against conspiracies and revealed secrets, Putin is reaffirming a commitment to a certain positivist history that serves as a newfound hallmark of the reasonable and the fact-driven.

Today, with the onslaught of misinformation and conspiracies, there has been an emphasis on fact-checking and historical Truths, which leads me to consider: What if, rather than leading toward an intentional destabilization of truth, the rampant spread of misinformation and conspiracy theories is setting up the grounds for a turn back to so-called hard facts and an objective history? As we reel from the flat-out lies, misconstructions, and intentional abuses of history today, it may well be that our reactions are misguided. In an era where fact-checking passes as critical thought and the ability to deploy a litany of facts and figures is the marker of erudition, we face the most treacherous assault on the necessary intellectual horizon for a truly interdisciplinary and inclusive approach to history. Even as we teach students how to critically assess the validity and reputability of sources, we are training them to make a series of judgments that flatten out the immense complexity and dynamism of what humanistic inquiry and historical research actually look like.

This, I argue, is the greatest challenge of history in the age of conspiracy and misinformation. I do not mean the difficulties of confronting historians' general feelings of helplessness in the face of various erosions and contestations of history; rather, I refer to the new difficulties in undertaking historical work as such, particularly for those of us whose work asks questions about the erased and the forgotten, about those hidden behind veils of secrecy and concealment. For scholars who seek to recuperate the histories of queer, trans, racialized, and marginalized peoples, our scholarly methods must often take on speculative and reparative methodologies. These are methods synonymous with work in queer theory, trans studies, and Black feminist thought. Lamentably, the onslaught against such methods has made terms such as *critical race theory* and *intersectionality* into household names and villains in the American political imaginary. Yet, beyond the discrete, piecemeal, and amorphous villainization of these

Betancourt

methods, what I am most worried about in history today is the reactive formulation of new positivist approaches.

We may speculate on how the spread of conspiracies might be a nefarious attempt to turn people back to an authoritarian adherence to facts, controlled by a limited few. However, what has been amply documented is the way in which far-right extremist movements have purposely co-opted the methods of critical race theory to promote and articulate their misinformation campaigns. In conversations with *The Guardian* in 2018, the Cambridge Analytica whistleblower, Christopher Wylie, made this fact chillingly clear. When asked what Steve Bannon was like, Wylie described him as "Smart . . . Interesting. Really interested in ideas," going on to say that he was "the only straight man I've ever talked to about intersectional feminist theory. He saw its relevance straightaway to the oppressions that conservative, young white men feel."[4] Here, we see an interest in removing theoretical frameworks and methods from their targeted, ethical functions and repurposing them to undertake oppositional roles. We can see how the far right has been able to successfully parrot academic and activist rhetoric to change cultural discourses around topics like critical race theory, cancel culture, and even consent. A traumatic result is that the far right has compounded the labor of activists and scholars as it co-opts their methods and practices and uses them for oppressive agendas.

### HOW TO HAVE THEORY IN AN ERA OF CONSPIRACY

What then do we activists and scholars do? How do we have critical fabulation in an era of conspiracy theories that function to oppress and limit access to lives that have been erased? In speaking of critical fabulation, I am addressing the method described and demonstrated by Saidiya Hartman in her essay "Venus in Two Acts," where the "fabula" becomes a structure for narrative cohesion that can stitch together the often disparate and fragmentary realities offered to us by the archive.[5] This practice allows Hartman to, as she writes, "jeopardize the status of the event, to displace the received or authorized account, and to imagine what might have happened or what might have been said or might have been done."[6] To paraphrase, Hartman's critical fabulation throws into crisis the so-called "what happened when" and exploits the presumed "transparency of sources" as fictions of history while making visible the disposability of lives in the Atlantic slave trade—*and* in the discipline of history itself.[7]

Various methods, including Hartman's, allow scholars to move aside the veil of secrecy and peer beyond the fragmented and taciturn limits of our sources and archives to map out spaces of potentiality and existence for lives that have been queered, gendered, or racialized beyond the bounds of the archive, pushed over its ledge with only scant fragments remaining. It is in this space of research and writing that critical thought is best displayed: where our labors are dedicated not merely to compiling, surveying, or syncretizing wide swaths of information but also to articulating what the archives have failed to tell us in their own loquaciousness. Across my work, I have repeatedly cited the queer theorist Elizabeth Freeman's powerful words about the utility of close reading, defined by "the decision to unfold, slowly, a small number of imaginative texts rather than amass a weighty archive of or around texts, and to treat these texts and their formal work as theories of their own, interventions upon both critical theory and historiography."[8] Freeman's words perfectly capture the necessary radicalness of queer methodologies, for it is in these interstitial spaces that the lives of peoples marked by trauma and erasure can best be given voice.

### REPARATIVE HISTORIES

In my 2020 book, *Byzantine Intersectionality,* I often sought to confront what narratives could be possible by working through the often fragmentary and dispersed evidence about gender identity, sexuality, and racialization. In that work, I particularly sought to deploy my generation's own critical language to undertake the massive work of recognizing and responsibly articulating these fragments. I often like to say that I wrote *Byzantine Intersectionality* for 2014 tumblr, where there existed thriving communities of queer/trans people of color, like myself, who were actively deploying a newfound critical language to comment on and revise our established narratives. One common meme on the platform in those days, for example, would present a series of variable bullet points or images depicting a historical queer couple. The punchline of the joke was always, "Historians [will say] they were roommates." For me as a scholar, this meme has served as an imperative not only to do better, to not be complicit with queer erasure, but also to rigorously question and interrogate the boundaries of what constitutes thresholds of evidence and affirmation for a historical narrative to embrace queer and trans lives. Here, the trope of

Betancourt

the historical secret becomes a poignant and urgent model for inclusivity and a more ethical historical mode.

Yet, these recuperative tasks often require an uncomfortable proximity to processes and legacies of harm. For instance, in my research on trans lives in the Middle Ages, I have frequently had to confront screeds of misogyny, homophobia, and transphobia in the archives to find the meager traces of queer and trans lives. As I have written elsewhere, in attempting to liberate these lives from erasure, we are often forced to re-perform or recount the violence of humiliation, misgendering, and slander that were deployed against trans people, particularly trans women, in our historical sources.[9] And, as Hartman asks, "how does one recuperate the lives entangled with and impossible to differentiate from the terrible utterances that condemned them to death"?[10] The romanticized retrieval of such lives requires us to display the litanies of shaming, misgendering, and incorrect pronouns that often defined their lives. Hartman reflects on these matters, writing that "the dream is to liberate them from the obscene descriptions that first introduced them to us," but, as she eventually goes on to say, it simply "replicates the very order of violence that it writes against by placing yet another demand upon the girl, requiring that her life be made useful or instructive."[11] Hartman contemplates failure and restraint while having just poignantly indulged in the methods she resists. Ultimately, she resolves that we must not seek to absolve but to "bear what cannot be borne."[12] It is this speculative, critical, and anguished process of thought that so often defines the powerful and subversive efficacy of queer, trans, and Black feminist practices.

### AGAINST FACT-CHECKING

Rather than thinking of conspiracy theories as a perversion of history, I propose that we recognize their work as seizing and deploying what the best historical work does very well: presenting us with a feeling of radical alterity and future possibility by shattering all our preconceived notions and expectations about the past. If we understand conspiracies less as a corrupt byproduct and more as a theft of some of our best methodological tools, we can then reposition how we approach the current moment and the spread of misinformation. We must acknowledge that conspiracy theories are powerful, both in their political effects and, more so, in the vigorously disruptive ways in which they unsettle the world around us,

produce horizons for possibility and change, and present alternatives to the realities of our past.

As a queer scholar of color, I refuse to give up the rhetorical methods that conspiracy theories deploy so well. I refuse to let those methods be taken from us and co-opted to promote racist, transphobic, homophobic, and antisemitic narratives. Instead, our work must reclaim the stolen methods to recognize that in their speculative working through of sources, many conspiracies showcase a broader, more unorthodox interest in the historical past than we have seen before and demonstrate the possibility for thinking in new ways about how political subjects relate to the cryptic workings of the state and to their emplacement within history.

The greatest intellectual danger to scholarship becomes a space where the fact-checking impulse becomes a normative affirmation that history is what we already know and that only litanies of line-by-line evidence can change that. Such an approach would have disastrous effects on queer theory and trans studies, particularly in fields like medieval and premodern studies, providing bludgeoning tools for the dismissal of queer and trans recuperations. No history of emancipation or oppression can be written without an acute understanding of the logics and discourses of hate that have sustained repressive institutions and norms. As responsible and ethical scholars, we must also be aware that our discipline is not immune to the sadistic, vitriolic, and hateful backlash against queer and trans people that has intensified over the past five years across the world. My concern is that the spread of conspiracy theories today and our reactive responses to them have cultivated a dually hostile environment standing in the way of undertaking meaningful work in intellectual spaces that have often needed to pierce through veils of secrecy and erasure to articulate their subjects.

### THE POETICS OF REVELATION

What, then, do we do to revitalize our speculative approaches while also combating the fundamental violation of trust and ethics that so many conspiracy theories seek to engage in? In her well-known text, "Paranoid Reading and Reparative Reading," the queer theorist Eve Kosofsky Sedgwick begins with her own struggle regarding conspiracy theories around the natural history and spread of HIV.[13] She describes the ubiquitous speculation around whether the virus had been deliberately engineered or spread, whether it was a plot or experiment by the US

military, and whether it had been transmitted by the global traffic in blood products. Sedgwick recounts how she turned to an activist friend to discuss these theories, only to confront the friend's utter disinterest. Her friend replied:

> I mean, suppose we were sure of every element of a conspiracy: that the lives of Africans and African Americans are worthless in the eyes of the United States; that gay men and drug users are held cheap where they aren't actively hated; that the military deliberately researches ways to kill noncombatants whom it sees as enemies; that people in power look calmly on the likelihood of catastrophic environmental and population changes. Supposing we were ever so sure of all those things—what would we know then that we don't already know?[14]

The words of Sedgwick's interlocutor are as poignant today as they were then, and there is a quiet power in this disinterested response that affirms how conspiracy theories have so often served as ways to express a fundamental distrust in power: to express the idea that the state, the military, and other actors might not have our best interests at hand.

What captures my interest in the friend's disinterest is the sensibility that conspiracy theories are ultimately not about the facts they mobilize but about the institutional critiques that they are able to articulate, precisely in the absence of said facts—facts that are absent because they have been purposefully concealed, carelessly forgotten, or maliciously erased from the records. For Sedgwick, the conversation becomes reoriented around the question of what the *revelation* itself of these possible facts would actually *do* in the world. That is, say they are all true (but also regardless of their veracity): What difference would that act of revelation make for an activist cause? As Sedgwick outlines, the questions become: "What does knowledge *do*—the pursuit of it, the having and exposing of it, the receiving again of knowledge of what one already knows? *How*, in short, is knowledge performative, and how best does one move among its causes and effects?"[15] Today, we intimately and viscerally know the answer to these questions, having seen the effects of such (alleged) revelations.

In the prologue of this book, I quoted the sixth-century Byzantine historian Procopius of Caesarea's account of the plague and the conspiracy theories that it engendered. For Procopius, it would seem that the solution to the dangerous efficacy of the dissemination of misinformation was to cultivate a state of unknowing: to let it be "impossible either to express in words or to conceive in thought any explanation."[16] As we have seen in this book, across the long history of Byzantium, erudite writers have often cultivated such states of unknowing when relating to matters of secrecy, evident in the military treatise and in the words of Michael Psellos. Implicit here is the understanding that just because knowledge of secret things is held close does not mean such knowledge is efficacious or nefarious. Indeed, I am reminded of Sedgwick's friend and her radical indifference. I call it a radical indifference because I believe there is something potent and profound in such indifference, or, rather, in its strategic cultivation. In a society motivated by clickbait headlines and algorithms that privilege engagement with posts over reading the actual article, many of our well-intentioned op-eds and public scholarship pieces—which are prime examples of mobilizing hidden histories for social change—are better at stirring up hate than at shattering age-old prejudices and preconceptions about the Middle Ages. Thus, a strategy of radical indifference may be more efficacious.

### CONCLUSION

Despite being in a world saturated with conspiracy theories, I do not find myself struggling against an absence of historical interest or inquiry. Instead, I feel an overwhelming desire to pry into different forms of secrecy and sketch out new possibilities and potentials for history. The best historical work will always shatter our expectations of the past, read our sources subversively, and provide new alternatives for an ever-changing world. Against charges of anachronism or presentism, it is possible for us to chart out a Byzantine way of approaching these methodological conundrums. Clearly, the state of unknowing is not an impediment to accessing knowledge of secret things or things lost to the flow of time—it is a distinctly Byzantine sensibility for contouring esoteric elements of the world that are partially concealed from view. As such, the lessons described in this book around secrecy in Byzantium should incite us to think of new methodologies that foreground the speculative, creative, and imaginative

poetics through which Byzantines dialogued on secrecy and unfolded their acts of revelation.

Here, I would like to propose that we use the Limburg Staurotheke as a conceptual, theoretical model for discussing the secrets of the Byzantine Empire, relishing the slow unfolding of revelation as a political act. The power of the Staurotheke is not in the objective reality of the relics it possesses but rather, recalling Sedgwick, in what those relics *do* through their revelation, dramatizing "the pursuit of it, the having and exposing of it, the receiving again of knowledge of what one already knows."[17] To approach Byzantine history through the model of the Staurotheke is to acknowledge the complicities of our knowledge creation with empire and the legacies of imperial Christianity, and to understand that concealment empowers revelation and that our modern preconceptions of the past often distract us from the surprising uses of its art.

Some secrets protect imperial power, some secrets protect the people oppressed under said power; some revelations of secrecy challenge the status quo, while other revelations are meant to out, slander, or victimize the oppressed. It is these power differentials that are so deeply critical to understanding how we approach secrecy in the past and in our present and that ultimately determine how we handle the secrets we keep and how we emancipate from the bonds of erasure those who have had to keep secrets to survive.

**NOTES**

1. Vladimir Putin, "On the Historical Unity of Russians and Ukranians," *Kremlin*, 12 July 2021, http://en.kremlin.ru/events/president/news/66181.

2. Putin, "On the Historical Unity."

3. Putin, "On the Historical Unity."

4. Christopher Wylie, as quoted in Carole Cadwalladr, "'I Made Steve Bannon's Psychological Warfare Tool': Meet the Data War Whistleblower," *The Guardian*, 18 March 2018, https://www.theguardian.com/news/2018/mar/17/data-war-whistleblower-christopher-wylie-faceook-nix-bannon-trump.

5. Saidiya Hartman, "Venus in Two Acts," *Small Axe* 26, vol. 12, no. 2 (2008): 1–14, at 3.

6. Hartman, "Venus in Two Acts," 11.

7. Hartman, "Venus in Two Acts," 11.

8. Elizabeth Freeman, *Time Binds: Queer Temporalities, Queer Histories* (Durham, NC: Duke University Press, 2010), xvii.

9.   See Roland Betancourt, "Where Are All the Trans Women in Byzantium?," in *Trans Historical: Gender Plurality before the Modern,* ed. Masha Raskolnikov, Greta LaFleur, and Anna Kłosowska (Ithaca, NY: Cornell University Press, 2021), 297–321.

10.   Hartman, "Venus in Two Acts," 3.

11.   Hartman, "Venus in Two Acts," 14.

12.   Hartman, "Venus in Two Acts," 14.

13.   Eve Kosofsky Sedgwick, "Paranoid Reading and Reparative Reading, or, You're So Paranoid, You Probably Think This Essay Is about You," chapter 4 in *Touching Feeling: Affect, Pedagogy, Performativity* (Durham, NC: Duke University Press, 2003), 123–51.

14.   Sedgwick, "Paranoid Reading," 123.

15.   Sedgwick, "Paranoid Reading," 124.

16.   Procopius, *History of the Wars,* 22.1–5, ed. and trans. H. B. Dewing, vol. 1 (Cambridge, MA: Harvard University Press, 1914), 450–53.

17.   Sedgwick, "Paranoid Reading," 124.

I would like to thank Mary Miller at the Getty Research Institute for inviting me to present the 2022 Thomas and Barbara Gaehtgens Lecture, as well as the Getty Research Institute Council for sponsoring the lecture. Chelsea Anderson, Margaret Combs-Brookes, and various Getty staff provided exemplary assistance the day of the event to help it run smoothly. My sincerest appreciation goes to Michele Ciaccio, who guided the book through publication with exceptional care, and to Lauren Edson, who made key contributions. I am also immensely grateful for the tireless work of Karen Ehrmann, who handled the complex image permissions for the book and thus made my life much easier. I thank Jon Grizzle for his design, which presents the material so elegantly, and Michelle Deemer for her work on the book's production. Finally, Laura Santiago's keen copyediting and insightful readings have made this text a better read, as have the comments and contributions of the two anonymous peer reviewers.

This is a book about secrets—those that enchant us and sometimes lead us to speculate and imagine worlds beyond reality, for better and for worse. It is also a book about the secrets we keep for our own sake, for our own dignity, and for our own survival. It is my hope that this text will urge readers to think across time about the challenges that afflict us today.

## ILLUSTRATION CREDITS

The following sources have granted permission to reproduce illustrations in this volume.

p. vi: Detail of fig. 19.
p. 16: Detail of fig. 11.
p. 76: Detail of fig. 4.

Fig. 1. © NPL - DeA Picture Library / Bridgeman Images.
Fig. 2. Courtesy of Biblioteca Apostolica Vaticana.
Fig. 3. Mondadori Portfolio / Art Resource, NY.
Fig. 4. HIP / Art Resource, NY.
Figs. 5, 8. Granger.
Figs. 6, 7, 11. Diözesanmuseum Limburg. Photograph by Michael Benecke.
Fig. 9. Map by David Fuller.
Fig. 10. Photograph courtesy of the author.
Fig. 12. © NPL - DeA Picture Library / F. G. Agostini / Bridgeman Images.
Fig. 13. Dagli Orti / © NPL - DeA Picture Library / Bridgeman Images.
Fig. 14. Dumbarton Oaks Research Library and Collection, Byzantine Collection, Washington, DC. BZ.1948.15.
Figs. 15, 17, 18, 19. Photo © The Trustees of the British Museum / Art Resource, NY.
Fig. 16. bpk Bildagentur / Staatliche Museen, Berlin, Germany / Ingrid Geske-Heiden / Art Resource, NY.
Fig. 20. Bridgeman Images.
Fig. 21. Courtesy of Biblioteca Apostolica Vaticana.
Fig. 22. Photography by Pixel Acuity. Courtesy of the Morgan Library & Museum.
Fig. 23. Courtesy of Biblioteca Apostolica Vaticana.